Foreword

ACCORDING TO THE MAP, Martha's Vineyard is an island twenty miles long and eight miles wide, five miles off the coast of Massachusetts. But that's like saying the sun rises over Chappaquiddick at 6:43 Eastern Standard Time and the tide goes out at 6:48, without describing what it looks like.

This book is about the feel and spirit of the place, what it was, what it is in the lonely beauty of the winter and the bright clatter of the summer. In a way, it's a collection of illustrated love letters to a corner of New England fighting to preserve its privacy and beauty.

The words are by Henry Beetle Hough, who has since 1920 been editor of the Vineyard Gazette, a weekly newspaper founded in 1846. He is, in my view, one of the most distinguished American newspaper editors and writers of the last half century. Many of the essays in this collection have been gleaned from his newspaper writings over the last decades; others have been newly minted for this occasion.

The photographs are by Alison Shaw, a young woman out of Maryland and a different generation, born more than fifty years after Hough. And the charm of this book, it seems to me, is in the contrasts, the interplay between his words and her photographs.

Both defend the fragility of the Island against the materialism of the present age. But there's a difference between them, dramatized in these pages.

Hough has fought for a lifetime against the real estate developers and others who wanted more people and business than he thought Martha's Vineyard could bear. But Shaw, while sharing Hough's anxieties, illustrates not what has been lost, but what has been preserved. With her camera she has chosen to wander the lonely places where, thanks to Hough, the old houses and quiet walks have been saved for future generations.

Henry Hough may be responsible for preserving more large tracts of the Island than anybody else. I didn't know Martha, but for me it's Henry's Vineyard.

There is one theory of journalism that the reporter should report and the editor state his opinions, but that neither should get involved in the politics of their work. This may be wise counsel on big-city papers, but Hough, like William Allen White in Emporia, Kansas, thought the Country Editor—the name of one of the best of his

twenty-four books—should fight in the town halls for his opinions; he gathered friends to his cause to deed at least some of their land in perpetuity to future Islanders.

But this is not primarily a book about his battles. It is an expression of his meticulous observations of nature as it changes with the seasons—the poetry of fog, the look of the old whaling houses, and the twisted windblown trees he sees every morning on his long walks with his collie while the Island is sleeping.

There are, no doubt, some on the Vineyard who would say Henry Hough is crying for a world that is gone, but that would not be fair. He is our memory, but it's the future that concerns him most, and his fear is that in our hurry, we may fail to look around and see what may be lost for our children.

For him, Martha's Vineyard is "the last stop We are the land in the sea that lies beyond the land. The Vineyard is not a way station, it is a destination. . . . It has nothing to do with rush and hurry, it is in a state of rest."

But of course, it's not in a state of rest. It's a battleground between nature and commerce, with Hough in his eighties still in the thick of the fight, and with young folk like Alison Shaw illustrating and taking inspiration from his dreams. It's a poignant and tender book, not merely Hough's own *Remembrance of Things Past,* but Shaw's shared hope of the future, two journalists old and young looking at one subject. Together, they've won almost every prize in New England journalism, and reading on, you may understand why.

<div align="right">

JAMES RESTON
February 1984
Martha's Vineyard, Massachusetts

</div>

REMEMBRANCE AND LIGHT

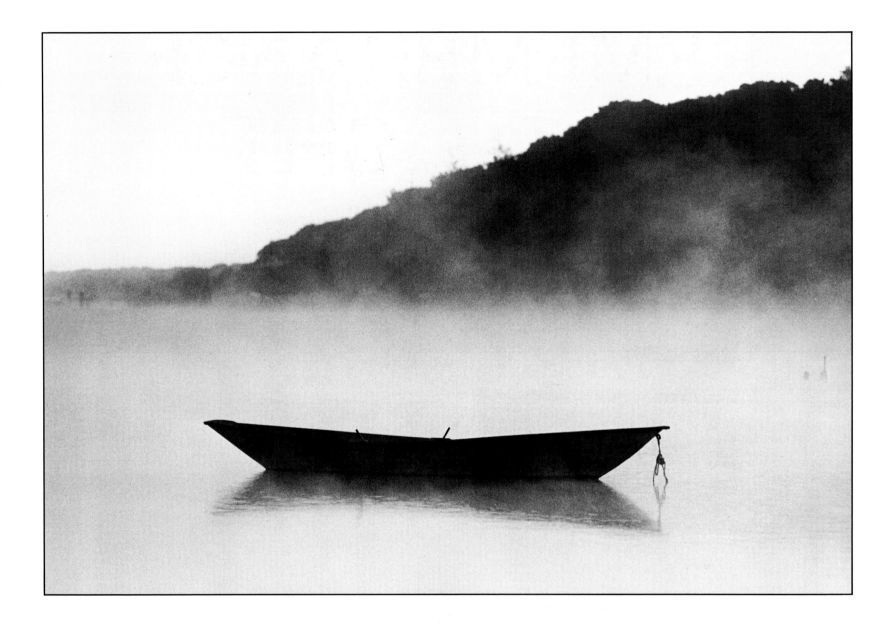

REMEMBRANCE AND LIGHT

Images of Martha's Vineyard

Photographs by Alison Shaw

Text by Henry Beetle Hough

Foreword by James Reston

THE HARVARD COMMON PRESS

Harvard and Boston, Massachusetts

The Harvard Common Press
535 Albany Street
Boston, Massachusetts 02118

Printed in the United States of America.

Library of Congress Cataloging in Publication Data

Shaw, Alison, 1953-
 Remembrance and light.

 1. Martha's Vineyard (Mass.)—Description and travel
—Views. 2. Natural history—Massachusetts—Martha's
Vineyard—Pictorial works. 3. Martha's Vineyard (Mass.)—
Social life and customs—Pictorial works. I. Hough,
Henry Beetle, 1896– II. Title.
F72.M5S48 1984 917.44'94'00222 84-4595
ISBN 0-916782-55-7
ISBN 0-916782-56-5 (deluxe lim. ed.)
ISBN 0-916782-54-9 (pbk.)

10 9 8 7 6 5 4 3

REMEMBRANCE AND LIGHT

THE STATE OF THE UNION has been dealt with in a message from the President, as required by tradition and the laws of the nation, but not for a good while has there been a message about the state of the Island, a matter of a different kind, important maybe not to millions but certainly to thousands. The state of the Island—there's a timely, hearty subject.

Things are coolish, of course, and the landscape has fallen in with the style of an old-fashioned hard winter. The lichens still grow in table-mat design on gray boulders, and the boulders lie as in ages past on the hills and in the woods. On a clear, calm morning Vineyard Sound is patterned in streaks of different shades of blue, all different from summer blue, and when the rain and fog settles in an occasional foghorn can be heard, muffled and far off, but nothing like the number that Vineyarders heard a generation or more ago.

At low tide there's the damp, salty smell that tells of the ebb, and this is one of the points of living on the Island. The elements speak up in various ways—the winter scents of beach and woodland, the pounding of surf, the wash of tide against wharf spiles, the calls of blue jays, gulls, crows, and at dusk, of lonely quawks, monosyllabic, outward bound for a night's fishing.

There's frost in the ground, but on the surface it's a case of freeze and thaw, and dirt roads are rutting. Wagons can't sink up to the hubs, however, for there are no wagons to speak of. Wood smoke rises from certain houses, lights shine at night but usually not with the glimmer the oil lamps used to bring about. There's ice in the swamp holes, some shrubs and trees have buds, and myrtle stays green in old dooryards.

On clear nights lately the stars have seemed so bright and near that any one of them could have taken a shot at us, and maybe did; who'll know until a thousand or so years have passed? The cosmos is one with the Island, but the mainland is not. The mainland remains busy, fevered, preoccupied and different. A peculiar place is the mainland.

The state of the Island differs not much in fundamentals from that of Thomas Mayhew's day. Long may the fundamentals endure!

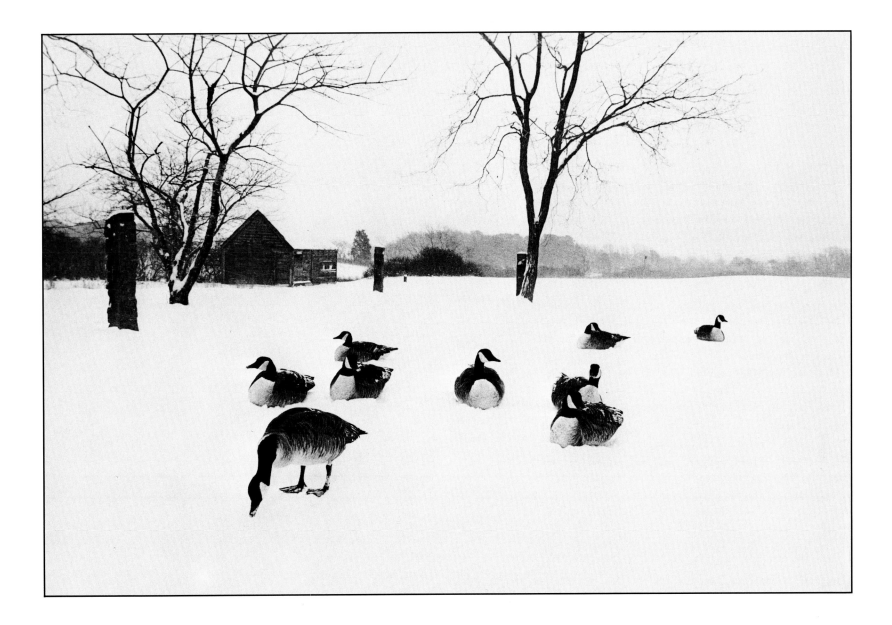

THE GREAT WHITE STORMS in which the snow comes clobbering down, wet and thick, are among the notable institutions of the northern winter. We had one of these storms on Tuesday, and nothing could be whiter. The lee sides of the houses and tree trunks and the slush in certain streets served only to exaggerate and glorify, by contrast, the otherwise universal shift of white.

In flounces, turrets, ruffles, blankets, and mounds the thick, wet snow adhered. The temperature hung about the freezing mark, leaning first toward rain, then toward snow—and such snow!

All snow, tradition has it, is white. But artists often paint it in tones of blue or lavender or gray or other colors, and by this means make us see that the tradition is wrong. Snow is the way it looks, and there are many ways of looking at it. But snow such as that which fell on Tuesday is always white, and there is no possible point of view or trick of vision to make it otherwise.

A great white storm it was, the first of the current winter, a storm reminiscent of the snows of childhood—the kind all children like and hope for. Soft snow, wet snow, white snow, is useful. It makes snowballs and snow men, it gets tracked in on the rugs, it inspires poets, it often, though not always, leads to coasting.

Give us a few great white snows and, doubt it not, mittens would come back into fashion.

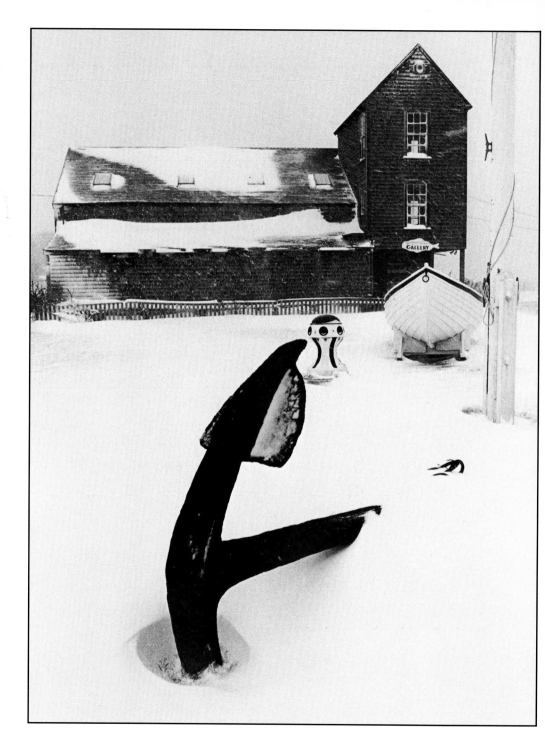

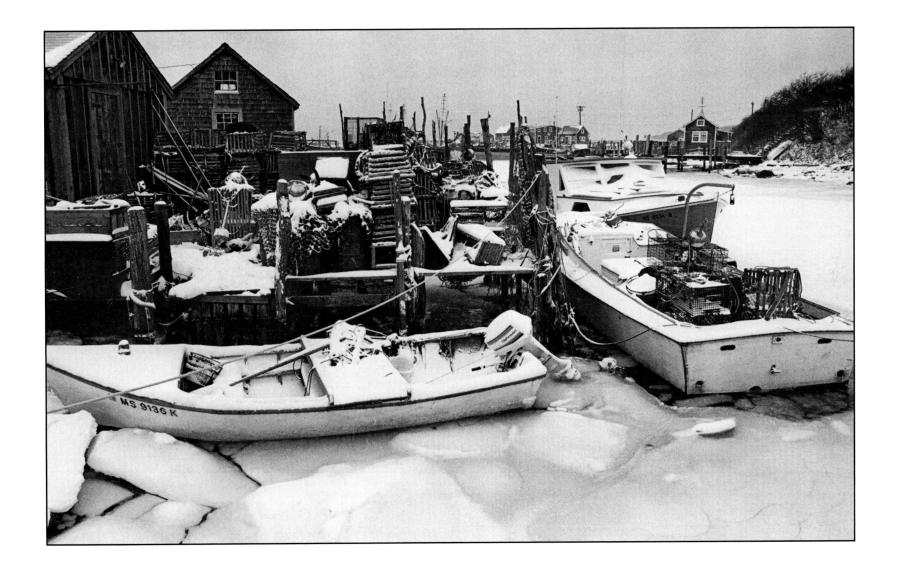

LET THE GARDEN REMAIN with its toppled plants and mixed weeds, let it be a winter gleaning place for all sorts of birds. Let it be brownly and blackly decorative, especially when the snow comes and when the stems and pods will rise above the crust of white. There is so much more to be said for the seasons of bud and bloom, but these tawny, russet weeks are likewise entitled to some celebration by reason of the pods, stems, haws, seeds, and general residue left for the walker outdoors to behold.

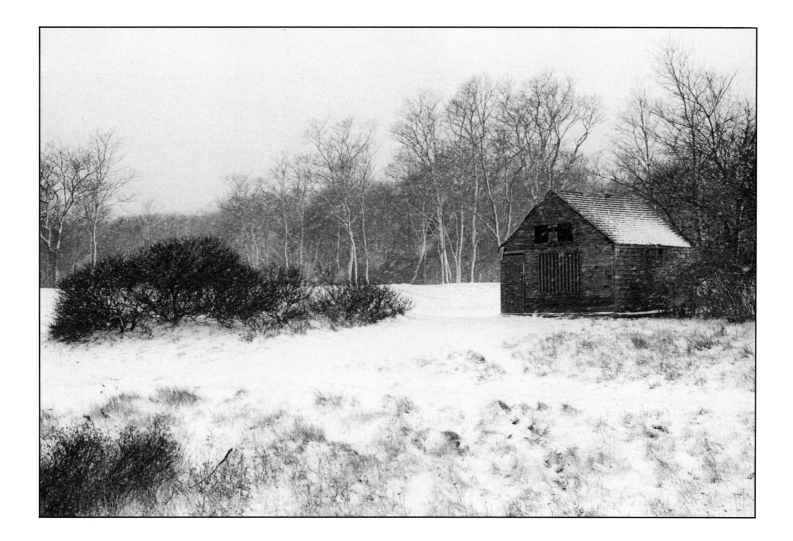

THERE IS NOTHING lush and bountiful about our Vineyard landscape at this season, as we have reported often enough, or perhaps too often. The winter foliage and flora are all in a different zone entirely. To describe a winter outdoors on the Island one turns habitually and accurately to the words "spare" and "lean." And yet the winter here, from beach to hill, and from old pasture to deep woods, is a time, a relationship, of abiding loveliness and satisfaction. Bold it is, and plain, striking in line and in those surfaces only now revealed to sunlight and the observing eye.

COLD WEATHER on the Vineyard always seems different from cold weather elsewhere—in Maine, for instance, or in Florida. It is more apt to be unusual, of course, partly because we have an unusual climate and partly because Vineyarders, as a race of humankind, are peculiarly well equipped to pick out and appreciate the unusual. When they can't find anything out of the ordinary run, it's a sure bet there's nothing of the sort to be found—or invented, either.

Many Islanders say they dislike the hard weather, but they would no more pass it by than they would pass by conscience. Whatever comes, they can take and be the better for it. Besides, there is a tremendous lot of history in this cold weather; out of hard winters the nation was born.

Bitter, elemental, and beautiful, with white violent seas and ice crunching against the shores, with trees snapping and flinging their limbs, with blue skies by day and startlingly bright stars at night, the hard winter blows and rides. Why should anyone like it? Because it is here—the same reason that climbers wanted to ascend Everest.

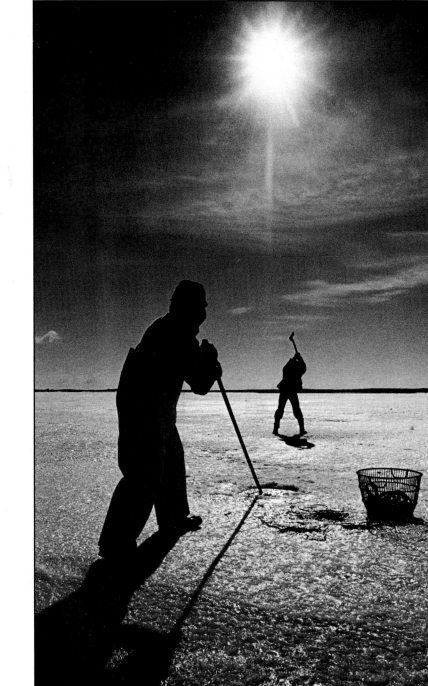

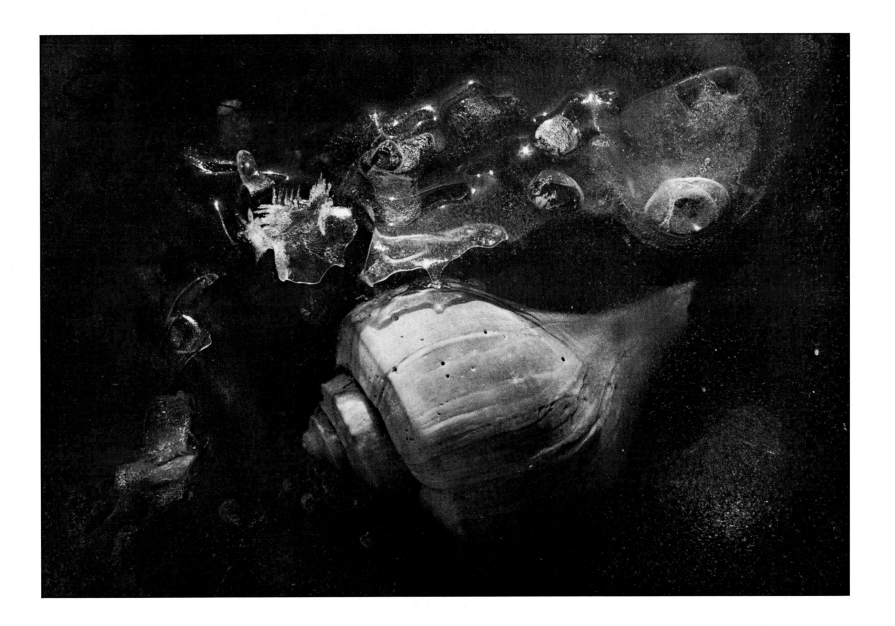

THE BITTER WEATHER of the winter, and the suspicion that there is more of the same to come, has reminded some Vineyarders of the cold winters in the early 1930s when wharf spiles rose up, and many a pier assumed a camel-back appearance. The rising of the spiles, and the resulting postures of the structures above was attributed by old timers to anchor frost.

A different theory was that when ice froze solidly to wharf spiles at less than flood tide, the rising of the water at the next flood would lift not only the ice but the wharves with it. No doubt this theory was sound enough in certain applications, but even when the ice was cut around the spiles each day, maintaining small areas of open water, the spiles often rose notwithstanding.

Ice forms at the bottom of streams, pools—and shallow saltwater areas—even when the temperature of the water is above the freezing point. According to the encyclopedia, it forms only under a clear sky, never in cloudy weather, and usually on dark rocks or dark surfaces, never under such covering as a bridge, and rarely under surface ice.

Scientists believe that this ground ice or anchor ice is caused by radiation. On a clear cold night, for instance, the radiation from the bottom may be excessive, so that the temperature falls below the freezing point. It is believed, too, that there is a thin film of stationary water resting upon sand or rocks which becomes frozen first of all, thus forming a foundation for the anchor ice.

Old time Vineyarders usually speak of anchor frost rather than of ground ice or anchor ice, but presumably it is all the same thing and if, come February, we again have temperatures far below zero under clear skies, there will be occasion to speak of it again.

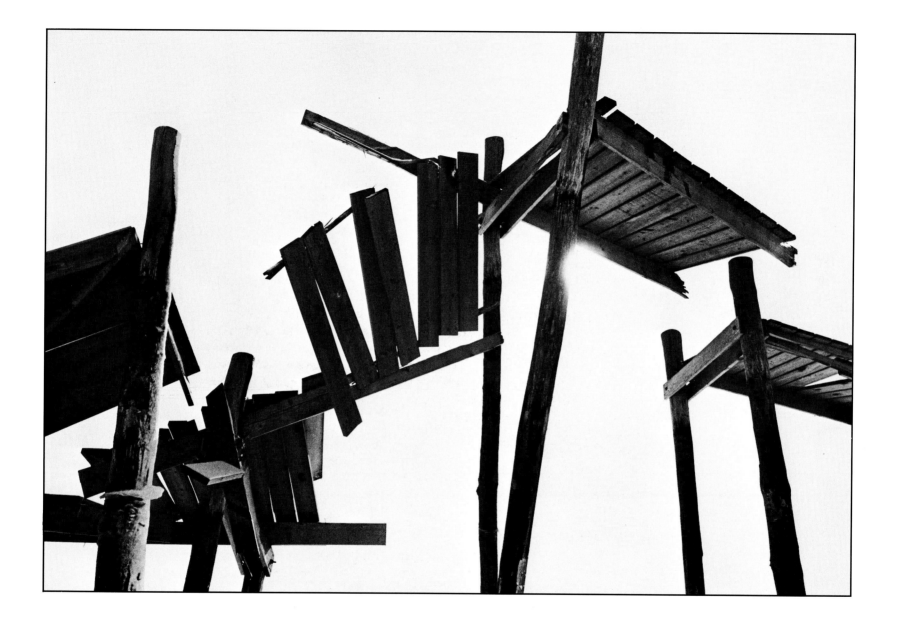

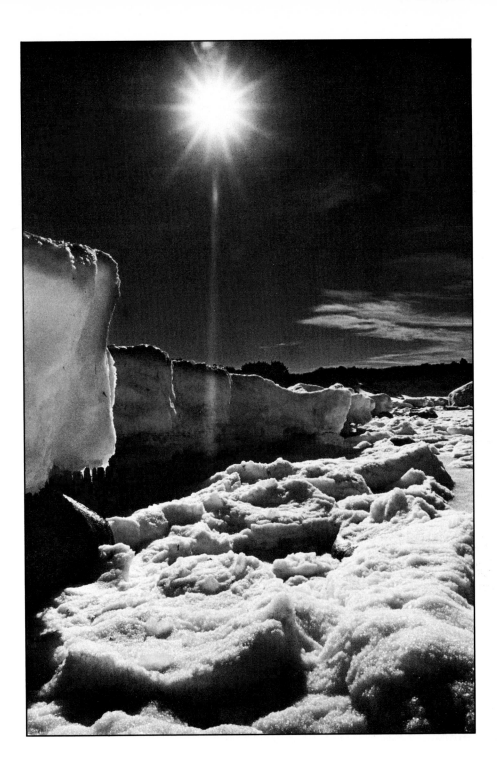

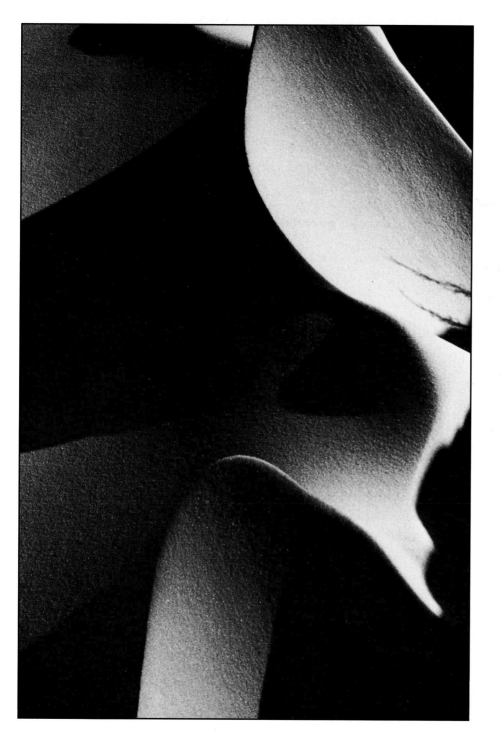

T HE BIGGEST and newest dictionary in the Gazette office discriminates against the word "scrunch." This is too bad now that there is snow on the ground and the temperature has been so low that footsteps "scrunched" through it.

That almost musical sound is one of the most characteristic of winter, and when you hear it you don't really need to look at the thermometer unless you are a hopeless precisionist. One would like to say that footsteps squeak under such circumstances and at such a temperature, but "squeak" is forever identified with tight shoes, and anyway it is described by Noah Webster's successors as "sharp, shrill and piercing."

Quite different is the satisfying passage of a shoe through snow that yields with a wintry comment remembered from old times, a sort of—well, really a "scrunch" as nearly as it can be described. This is part of a diminishing heritage of cold (at least in our latitude) and some of us cherish it, as we cherish the memory of the sound the axles of the milk wagons made on chilly mornings of childhood before the automobile age.

Was it the grease in the axle box that complained so loudly in those old winters, causing nearby inhabitants to turn in their beds and pull the blankets more tightly around their throats? Or was it mostly the iron tires turning through the packed, frozen snow? Such questions are inconsequential now, for the sound itself belongs to yesterday, youth, and the wagons, mostly milk wagons, that drove through the streets at dawn.

IF YOU SEE a path through the woods or over a rocky, brambled hill, or at the top of a bluff alongshore, it is probably an old one; for we live in a society that does not go afoot. The civilization of our forefathers had a gait, but ours has only an r.p.m.

This is a good time of year for seeking the old paths cross country, though if your expedition has a definite purpose and an immediate objective, you will naturally get into your car and drive by way of a road that has been straightened as much as feasible. If there were such a thing as a straight path you would know it had not been trod by a Thoreau or an Emerson; and by the same token, the winding path means that old walkers on that route had something in them both of Thoreau and Emerson. It could not have been otherwise.

The purpose of a path was usually to save distance but not as distance is saved today. The walker whose feet trod out the path—and that was how paths were made—circled a thicket or even a tussock, headed for that boulder which probably wasn't nearer but nevertheless served as an important marker and even eventually as a sort of companion, and suited the choice of terrain to the reflective eye as well as to the easy footstep.

Sometimes paths were for observation, and those alongshore were usually of that description; they skirted the top of the bluff because of the view, aesthetic and practical both, since the harvest of the sea on the beach could be of real value. But the walks of old times did not choose the heights alone; they turned aside to the swamps where wild grapes, huckleberries, and blackberries grew, and to the huddled beach plums and bayberry thickets.

This is a good time of year to seek out old paths and, in the footsteps of the walking generations, to feel the comfort of leisurely thought and well met countryside.

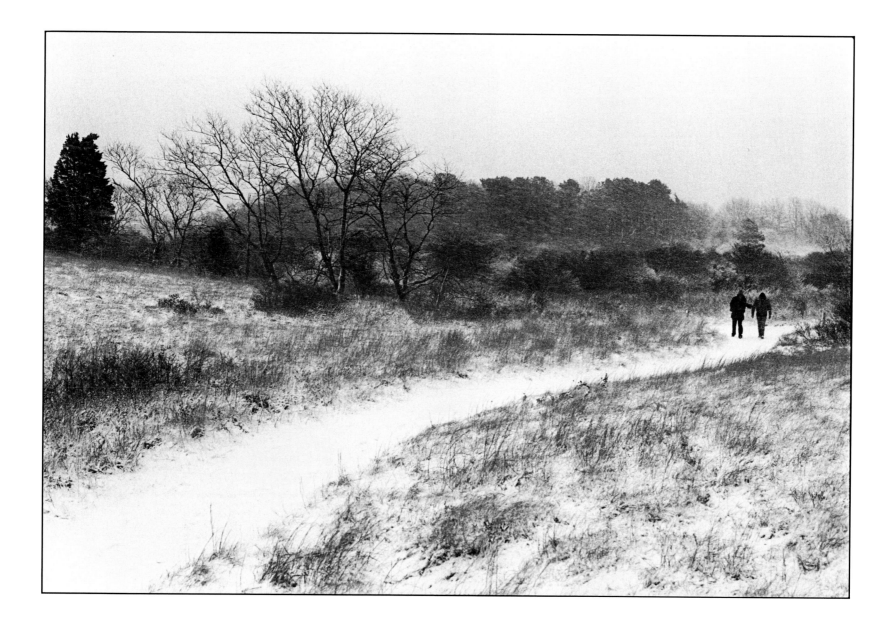

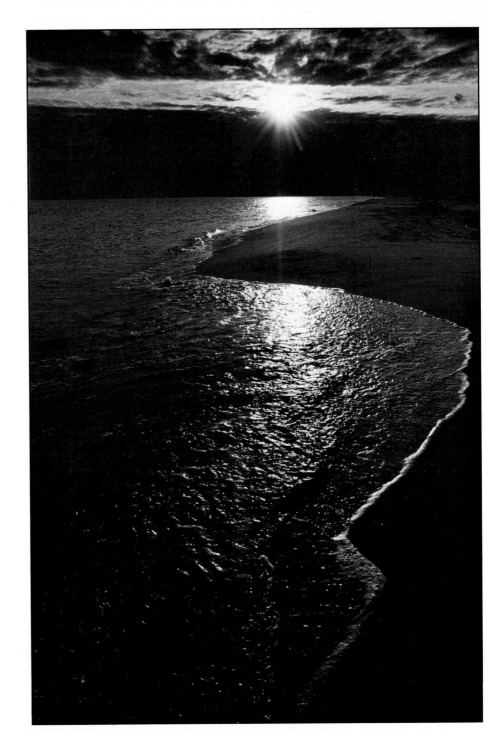

Sounds, or some sounds, are different at different times of day. The most familiar example is, perhaps, the wash of an idle sea on the shore of the Vineyard, restless in the morning, reflective and soothing at dusk, a mere distant memory or reminder at night. Time and again the successive phases can be observed, though not registered on any instrument more reliable than the attentiveness of a human being.

Even the soughing of the wind, a hollow moaning at dawn and through a morning of uneasy weather can settle at night into the common sigh of all things in all ages, a communication of the spirit, although the number of decibels involved is presumably the same.

Instances could be multiplied. There will be those who say that it is not the time of day that matters, but the emotion of the listener. We still maintain that it is the time of day, for this and the listener are inseparable; they are prisoners of time and environment. They are the same.

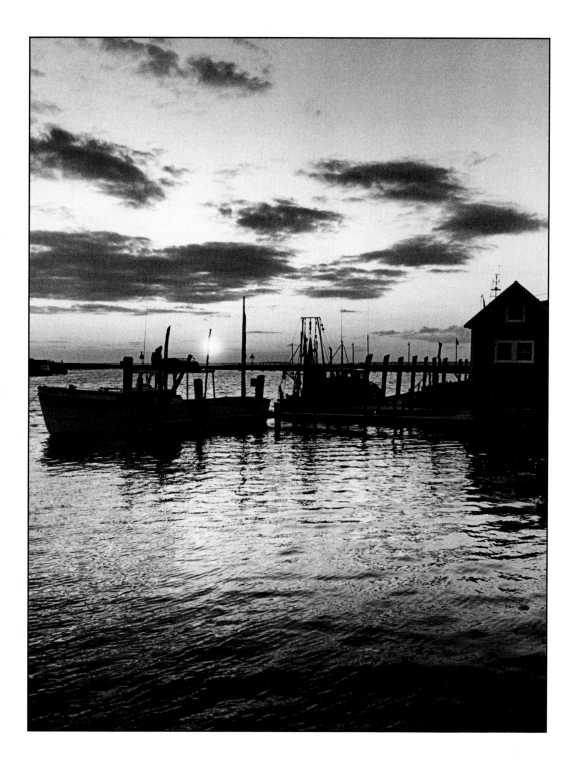

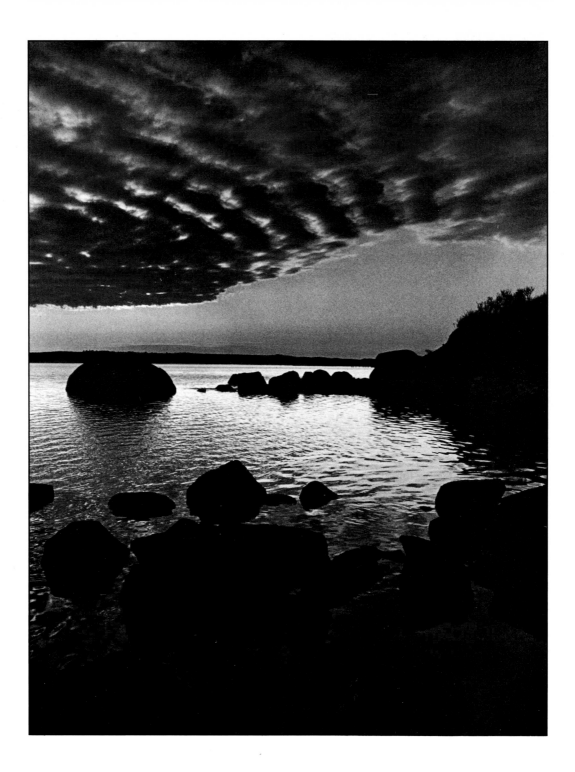

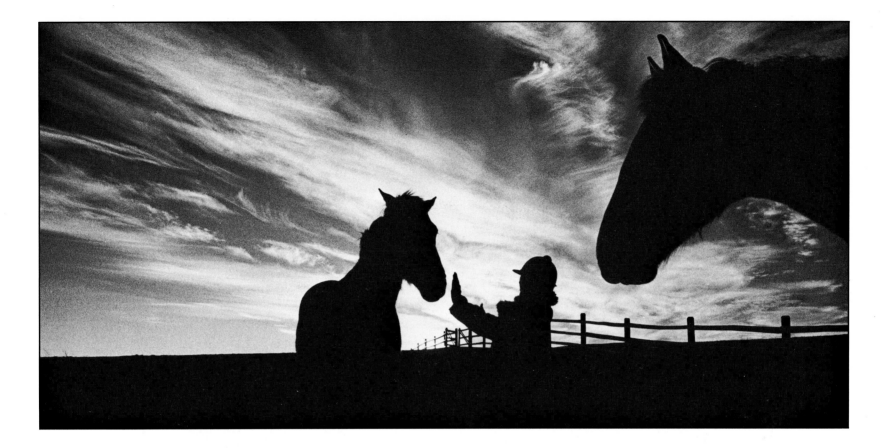

Spring fever was rained out this year. Nobody catches the sublime contagion by staying indoors while the drizzle falls or the lash of wetness is driven cross country by a raw wind. Nobody goes out in the rain to dig sassafras root for spring tonic or to be reminded of his lost youth and the yearning sweetness of Aprils past. In order to have the fever, first you need to have the spring.

But a time comes when mankind steps out of doors, and the sky has cleared, the sun emerges, and nothing is more certain than that the earth is beautiful. That is a lesson-sermon of every returning green season. There is life in the old earth, a quickening, an endless capacity for loveliness. Likewise there is duration, protection, respite.

The principle of gravity keeps man on earth, but there is no gravitational law to keep his mind on the earth, and for long interludes he forgets the marvel of the soil and of growth. It is good for him to be reminded again by the time of year that suddenly says, "Behold!"

AFTER ALL the springs of so many years and generations and centuries, there should be nothing new left to be said about the pinkletinks. But the old story of their music, thin and silver bright, coming from the ponds and swamps these days does not seem an old story at all. The miracle of recurrence is with us, and the whole secret of the miracle is that of rebirth, renewal.

Elsewhere *Hyla crucifer* is generally known as the spring peeper, but on the Vineyard from time immemorial the popular name, indeed the only name, has been pinkletink. Do the pinkletinks make a brighter music here than on the mainland? We believe they do because, for one thing, there are relatively more of them. In spring the Vineyard abounds in moist and swampy places, the legitimate domain of the pinkletinks. Our insular climate, too, with sunny-warm days and cold nights, provides the sort of atmosphere in which spring peeping excels. So we have ideal conditions for our pinkletinks.

Again, they have not been much interfered with here, whereas on the mainland a bulldozer civilization has leveled hills into swamps, dumped refuse into primitive pools, cut off trees and brush, turned original countryside into conformist suburban developments.

The music of the pinkletinks is the true refrain of the primitive—not the jungle or the desert or the awesome wilderness, but the primitive with which we may live in peace, security, and satisfaction, if only we will. Long may it sound in each returning spring.

Everyone is in favor of pinkletinks, no one is against them. But more is required than this: you have to be in favor of nature, even give or take a few inconveniences, and it seems hard for many people to accept so large a view.

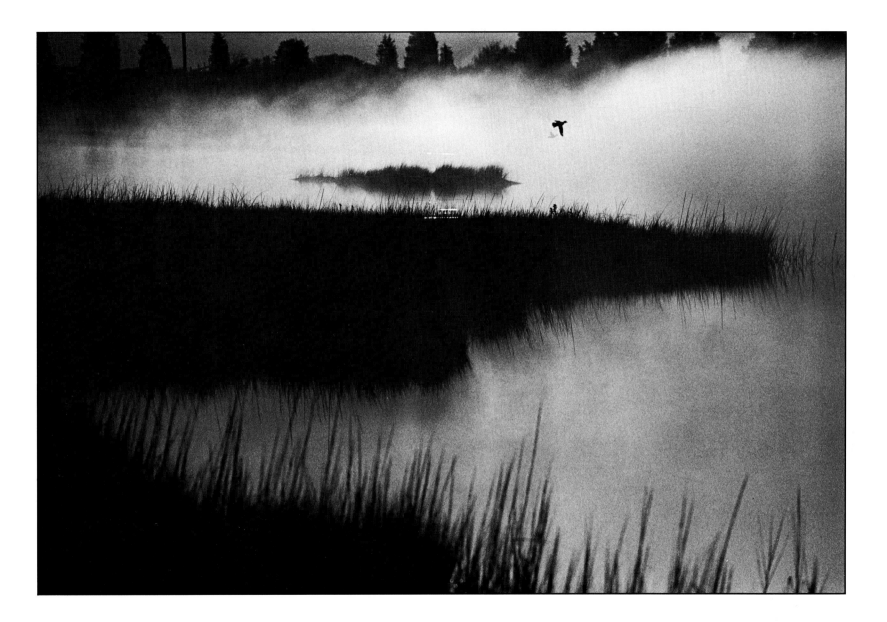

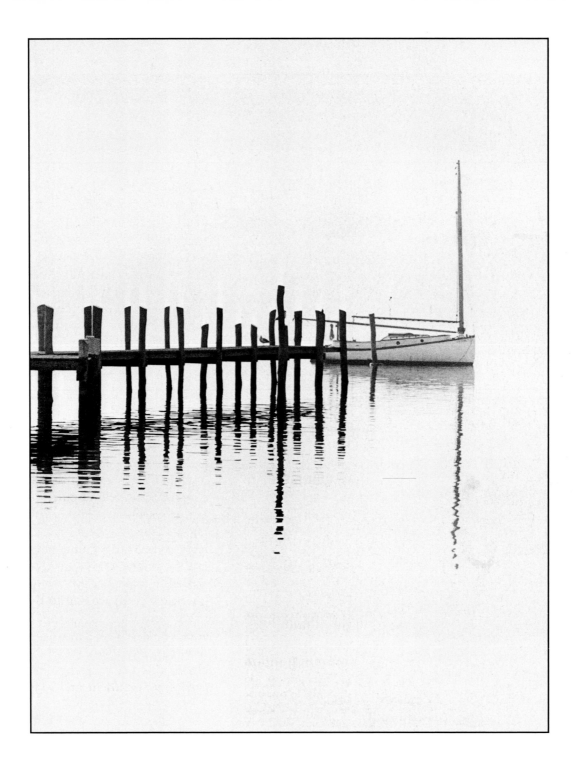

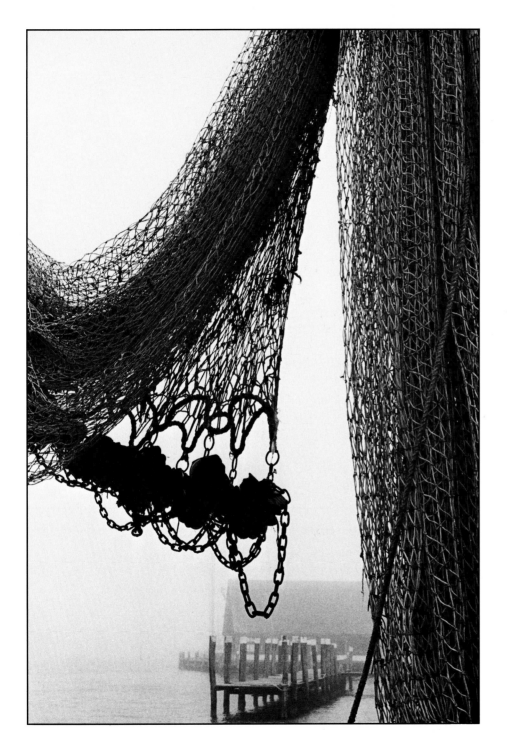

Fog is one of the poetic phases of nature and we could not do without it in the long run when spring is trying so hard to slip in edgewise.

The poetry of fog comes along in warmer weather when vacationers are about, and spiles drip, drip, drip, drip and lighthouse bells toll solemnly but not mournfully across the shrouded aisles of distance. Then is the time that woodsheds loom and small trees assume the proportions of great ones with unfamiliar outlines. A bright sun on the heels of retreating fog is ready to set lawns and fields sparkling, and sometimes the fog withdraws only a short distance and lies in a white bank with sunlight and blue sky above it.

Such humans as can take pleasure in moisture are fond of fog, or a certain share of it, during the summer months when they can walk abroad and feel themselves dissolved in the elements. At such times the cooling effect is sometimes a pleasurable contrast with sun-baked afternoons.

But in spring there is nothing to fog but wretchedness and betrayal. Then is when we hear of warmth coming to mainland places so that our expectations are aroused—but the natural temperature-regulator known as fog appears from the salt water everywhere and proceeds to regulate temperature. The regulation is always downward, never upward. We are deflated, cooled, dampened, leveled off at degrees Fahrenheit far below what we feel to be our natural deserts.

We wish that spring would burst the fog barriers, and soon it will. When the daffodils are blooming, as they are everywhere, and never with richer golden cheer, the great change cannot be long held off. Spring is impatient and so are we.

IT SEEMS that there is an organization called Islands Research Foundation, Inc., which was chartered in the District of Columbia way back in 1914. Among the subjects on which the foundation is prepared to offer material is "major aspects of islandry." There's a new word that isn't half bad—"islandry." Let's put it carefully aside, however, and not permit it to be tarnished.

Islandry, we can say, is a subject that lies not all on the surface but runs deep and far into the centuries, the tides, and the sea winds. It is not proper grist for a quick TV program or a prize contest. You don't become an expert through research, either, but only by living on an island.

Islandry, like history, has no generalizations. Each island is by and of itself, separate, aloof to a desirable degree; and that is why mainlanders are able to escape to islands from time to time and regain health, sanity, and that most valuable of possessions, a horizon.

We note at the foot of the letterhead of the Islands Research Foundation, Inc., this praiseworthy sentence: "There are three Worlds in physical geography, the Old World, the New World, and the Island World." This we will clip out and paste up beside that earlier sentence which has come down to us from the New Haven Railroad and the old New England Steamship Company: "Of all the earth's surfaces the Islands are the aristocrats."

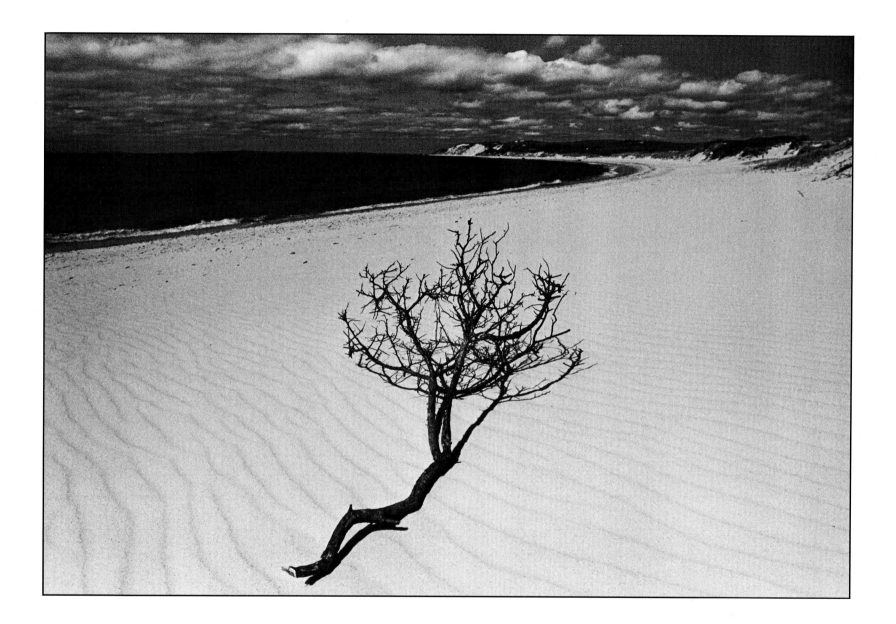

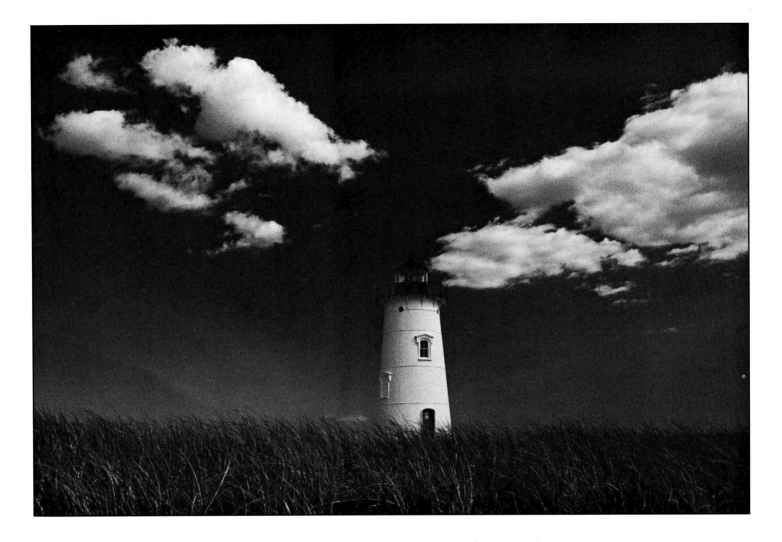

GREEN IS THE COLOR for spring, and that will come by degrees and reach its fullness later. Meantime, for those who live near the sea, blue is also a color for spring, and the transitions take place as the light changes and the air clears of winter dampness. Blue above, and blue all around—but this is not the whole story, for the degrees and delicacies of blue are the significance, the difference, the inspiration, and the revelation of the hour and minute.

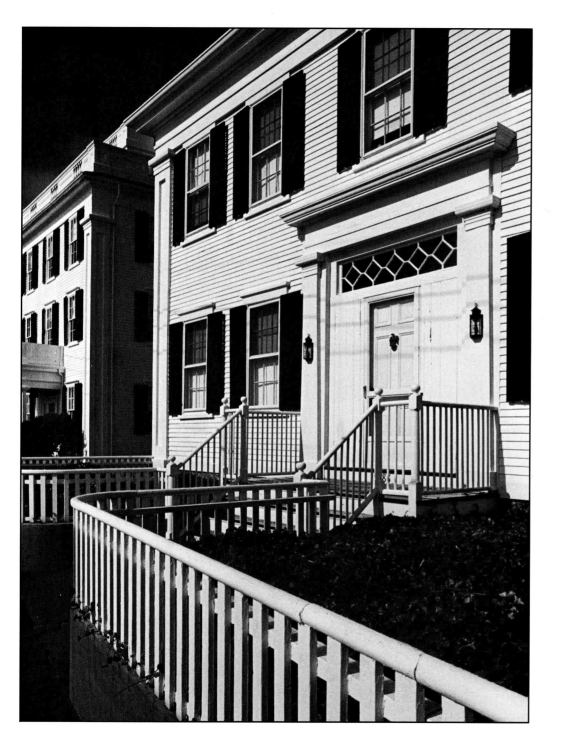

THE ANNUAL SPRING CLEAN-UP and paint-up calls are going around, which is as it should be. It is in the nature of man when spring comes around to plan a good deal and to accomplish—well, something. The urging of propagandists, those people who sell paint, soap, brooms, nails, and things, tends to build up such pressures as community opinion, pride, sense of duty, and so on, promoting desirable activity in the clean-up, paint-up line.

But the best urging of all comes along when there is even a single warm, bright, sensuous spring day. Then, if ever, man likes to stir paint, move the step-ladder to the sunny side of the house, buy seeds at the store, lean on the comfortable handle of a rake or hoe, or carry on affairs which seem to be in the line of duty but really are a romantic interlude with spring. The years pass, but at this season the heart of man is forever young, and spring fever masquerades under many plausible rationalizations.

The cleanable and paintable parts of the Vineyard look pretty neat and bright, and are being made more so. Hail to thee, blithe spirit, with the paint brush handy in the pot, or the rake handle comfortably under the chin, or the wheelbarrow in the doorway of the garage! Come one fine, warm day, and no spirit could be blither.

APRIL IS A GREAT MONTH for the manufacture of fresh air—air so fresh that it seems new. Of course we don't get it every day, but when conditions are right, how exceedingly right they are!

We can recall no scientist who has ever attempted to explain where fresh air comes from, except maybe to offer a generalization that it comes from out of doors. Obviously that generalization does not go far.

Our own judgment is that fresh air is produced on April mornings, between sea and sky, and that it is filtered somewhere out beyond Cape Pogue or beyond Noman's Land, so that it reaches Martha's Vineyard with more exciting qualities than vintage wine.

If it were not for the April air, we could not have the scent of arbutus or the color of daffodils, for these are spring essences, quite different from the more mature, settled, and frequent essences of the summer season. Those of April are headier, also, producing no intoxication but the eternal inspiration of spring.

Spring—well, it's true that we don't have spring on the Vineyard, at least not in the sense in which many people use the word. But we do have April, and when April is at her best she supplies sunlight and air that remain memorable as long as life lasts.

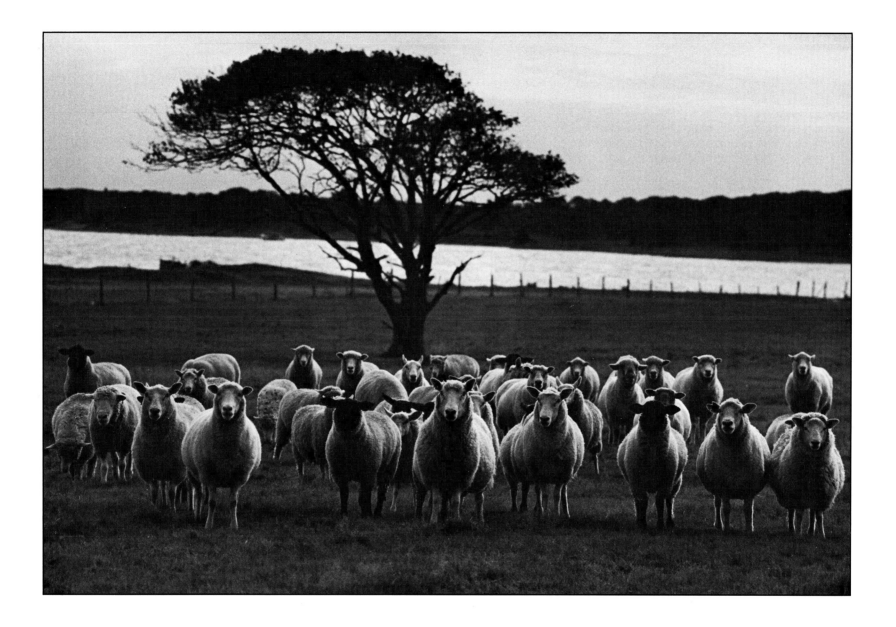

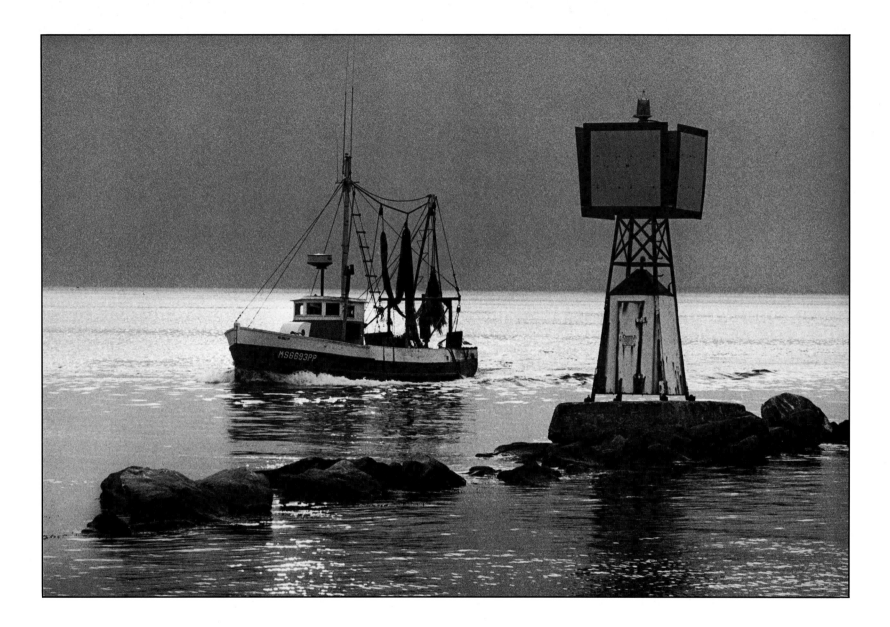

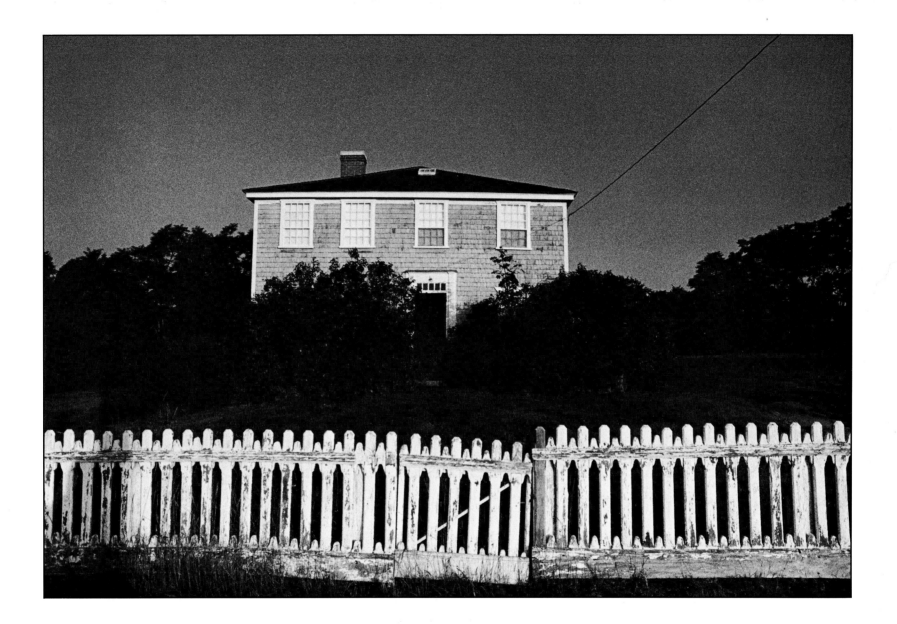

IT IS STILL A MYSTERY, they say, how the terns know that summer has come to this region and return at an appropriate time to keep their romantic annual appointments. They are not tipped off by changes in temperature, for often they fly north in unseasonable cold; nor by longer hours of daylight, for this idea has been disproved by observers and experimenters. They just know, as if by private information as mysterious as the necromancy of their feathers.

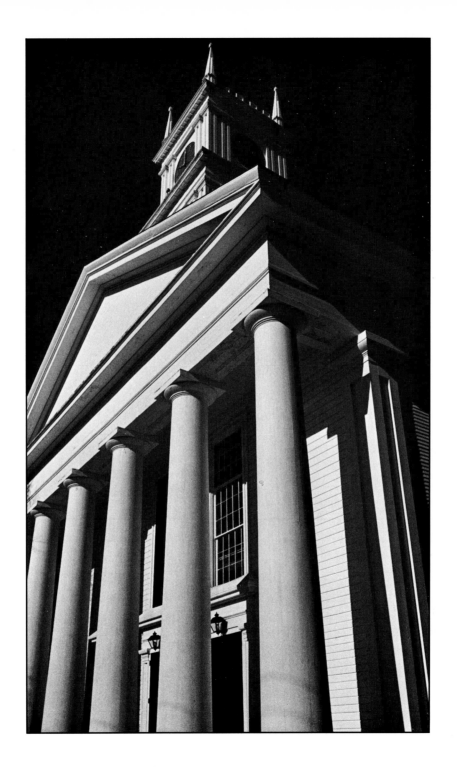

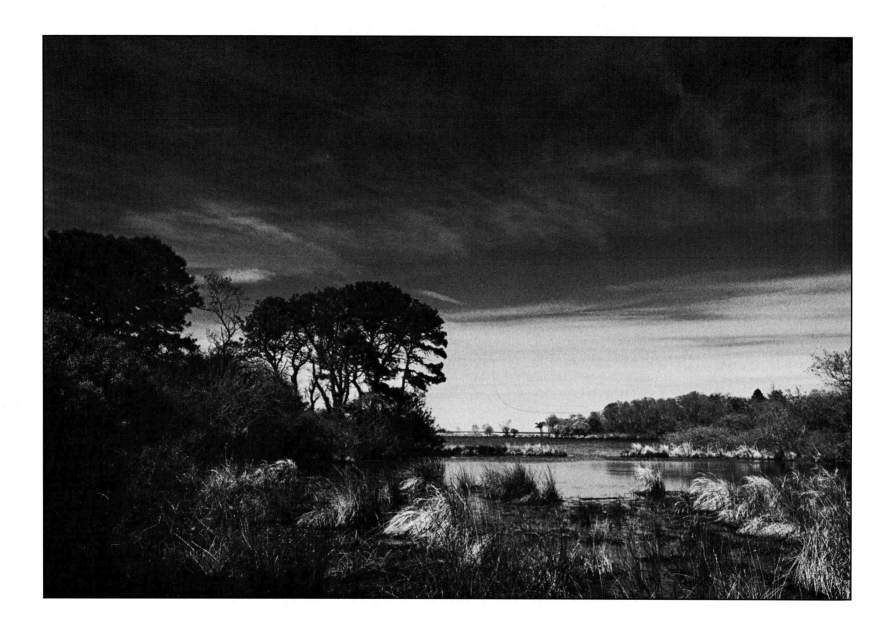

THE GREEN MONTHS have come. After so much hesitation and creeping and dallying, the green has overtaken us with a final surge, to be held back no longer by chilly nights or dry ground or any of the countless reluctances of nature. The eagerness that has finally superseded all else is plainly to be seen. Check it off in the daily growth of that erstwhile static lawn, the emergence of leaves on maples, lindens, horse chestnuts, elms, and all the trees of the orchard.

All winter long, and into the spring, we have needed sunlight for cheer; it was pretty generally a case of sunlight or nothing. Now, whatever there may be of fog, rain, mist, and cloud, we have the green. The novelty will wear off—it always does—but just at present this quality of freshness and newness is almost as overwhelming as a first glimpse of the sea. Summer's tide is coming in, or up, or over.

The green forms carpeting, back drops, canopies, arches, and, not least, a filter here and there for the brighter, longer light of approaching summer. It is still too early to talk of shade; that will come later, but the premonitory spatterings are with us—the temptation of summer brushing aside the coyness of spring.

The effect of the green surge is not only visual. One may say, in current terminology, that it raises our status, gives us feelings of prowess, confidence, and esteem. We have been, so to speak, underprivileged for too long, and now we are practically on a par with the tropics. On a par? No, we surpass them. We not only have orioles in green foliage, but we have a sense of contrast translatable into sentiment, heroics, philosophy, or what you will. It's good to live on a green Island again.

THE TIME OF ARRIVAL is a most pleasant time for all concerned. On the streets in the morning we see the newcomers looking around in appreciation of our comparatively rural and completely insular scene. Day by day they come, more and more of them, the summer migrants called by sea and open country, by shore, hill, and country sky. In a deep sense it is home that calls them, for the home of mankind is the place most remote from cities, the old domain of nature. Scientists, we remember, even maintain that the home of man is the sea itself; if not that, then an Island comes nearest.

And so the expression in the faces of the new arrivals is one of recognition, whether they have been here before or not; recognition of the elements of nature as they used to be, of scenes important to the childhood of the race of man.

But in any case, arrival is one of the great experiences. Simple in itself, an unpretentious event of transition, it nevertheless comprises and distills the essence of newness. A spring or summer arrival is newest of all, an encounter of the slim edge of freshness like the rim of the horizon; but even a weekend arrival, often repeated, does not stale. The moment of stepping from boat or plane, the entry into Island territory, retains a sensation of discovery.

The time is a good time, and always will be. Anticipation mounts, and it matters not how briefly, into the age-old vista of fulfillment.

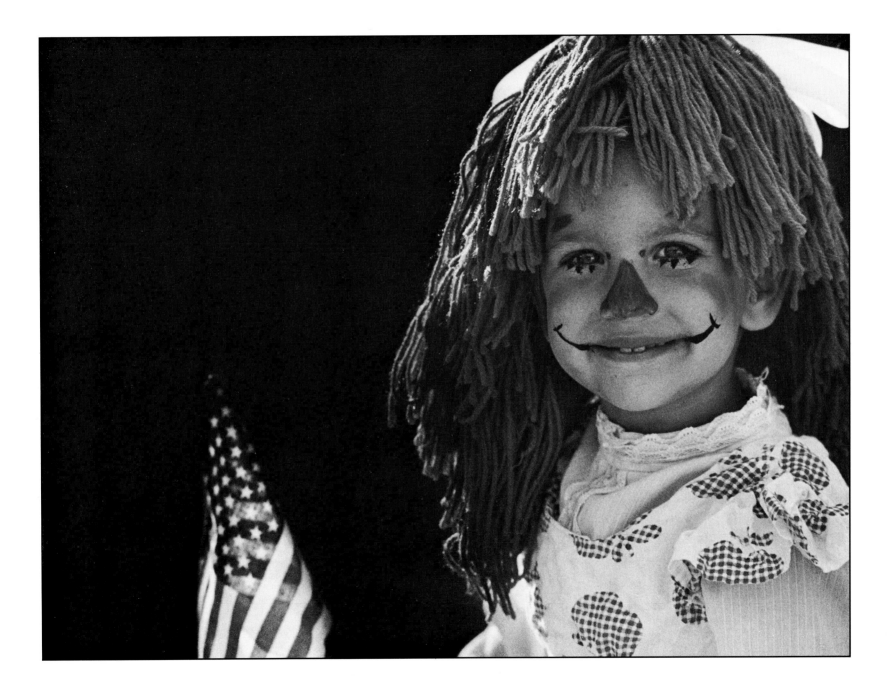

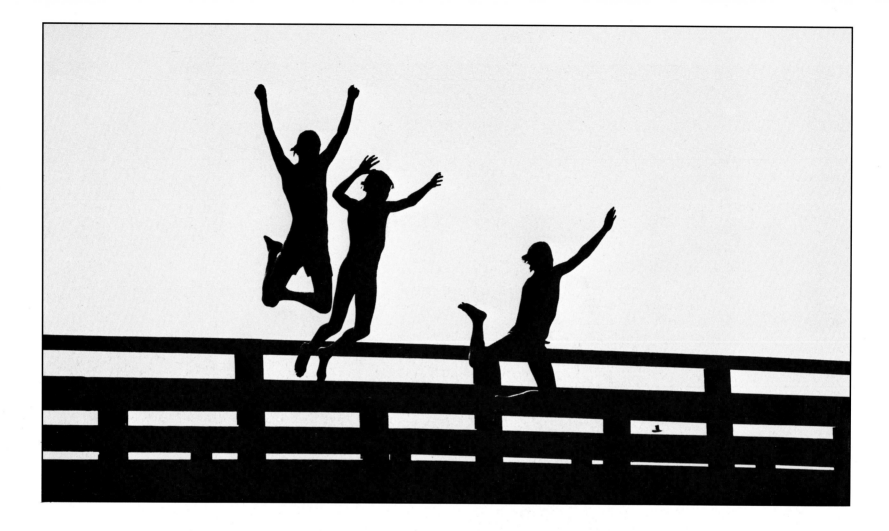

G OING IN for one's first swim in the summer is always a case of "Ready or not, here I come." But a surprising number of bathers and swimmers seem to take the plunge with agreeable results and few cries of distress. There used to be a divergence of opinion as to whether it was best to wade into the water gradually or to race down the beach and leap in all over and all at once. Presumably there is still a divergence, but the predominant choice is the abrupt, all-or-nothing plunge. For the first swim this takes courage, but it is dramatic and shortens the period of suspense. So it's all to the good, especially since the first swim of the season often seems, and symbolically is, the first swim of all. The firstness of it becomes the essence of the experience.

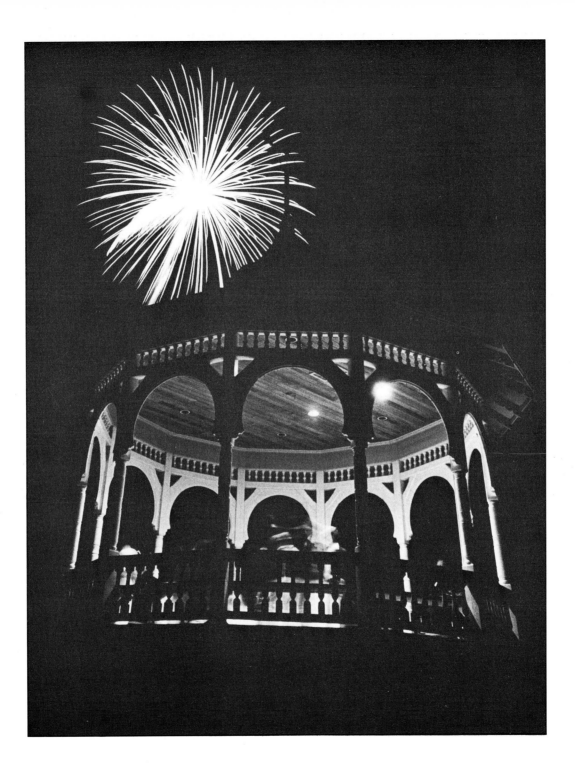

ONE OF THE MEMORABLE places of summer is the water's edge, yet it is less a place than an appointment, a shifting conjunction of elements which may be shared by those who anticipate it from year to year. The essence of the foreshore and of the experience most land dwellers have during their lifetimes with the sea is the water's edge.

It is in one moist, uncertain line at this moment, and another an hour from now. Those who have time to lie on the beach are aware of its changing; nothing better symbolizes the inevitability of change. The stars in their courses travel a slow, far track, and the sun and moon have a schedule that occupies a day or a night, but the water's edge pauses little. It is moving while we wait, with precursors or lazy followers of ripples or waves.

One of the best places to meet summer face to face is at the water's edge, now at the flood, now at the ebb, with the moods of each so different that the nature of the world seems to have changed in between. The flood brings its imminence and swelling fullness, the ebb displays with an artful impression of leisure its tidal pools and languishing mosses.

To the water's edge come vacationers of all ages, but for childhood the appointment has its most enduring spell. Sand castles are not what they used to be in the life of summer, but a different romance has come in; pails and shovels are replaced with flippers and skindiving goggles, and nowadays it is mostly adults who walk slowly, collecting shells and pebbles. All ages, though, will remember nothing more clearly and nostalgically than the bright hours spent at the water's edge.

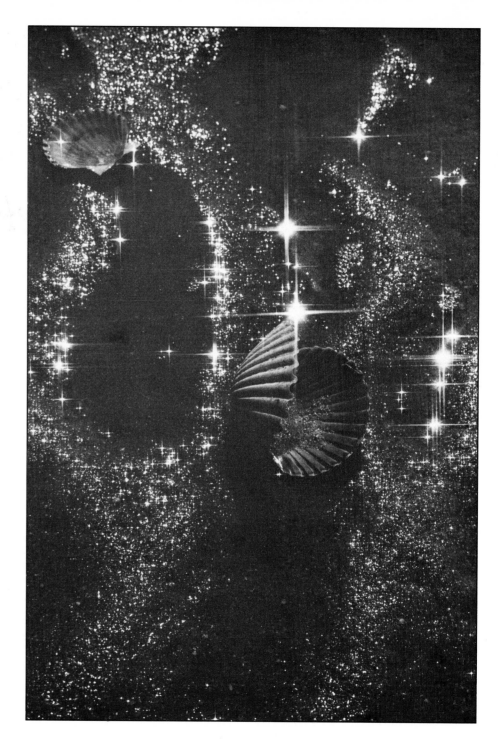

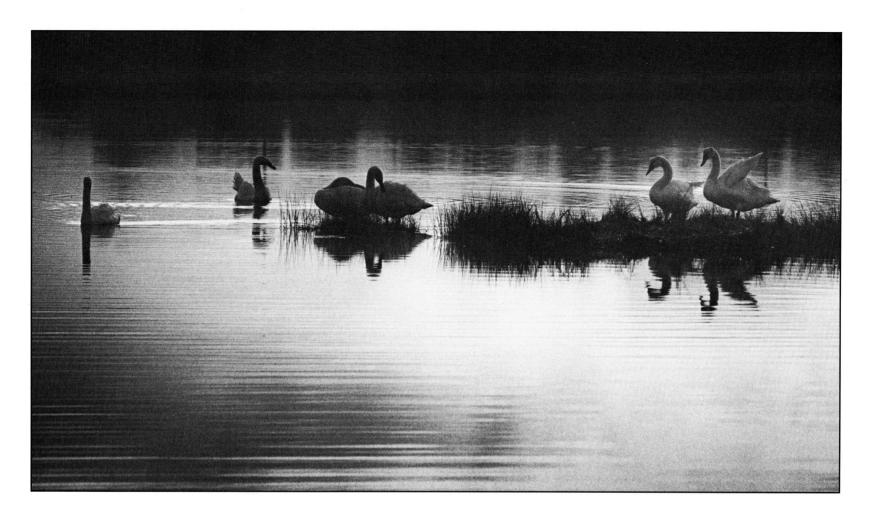

THE SEASON has leaped ahead and, generally speaking, is exactly right for early morning walkers, early morning being the best time for walking, because the edge is not off the day or off the walker either. Anyone who would like a refresher course in living can hardly do better than turn himself out of bed a little before sunrise and walk abroad to meet the first light striking slantwise from the east.

The companionship of the early morning walk offers the antithesis of segregation or even of selection. Birds are the most conspicuous sharers, but there are also bugs, snakes, rabbits, squirrels, more bugs afoot and on wings. The richness and fullness of a life into which poison sprays and ideas have not entered are too suggestive of divinity and wisdom to be ignored.

THAT WAS A SHINING sentence Nathaniel Hawthorne wrote in his journal in Concord on an August day long ago: "For a few summer weeks it is good to live as if this world were heaven."

There are many things that keep this modern world from being heaven or even a remote resemblance to heaven, and we of the Vineyard are not wholly apart from the shams, ills, and noises, despite our Vineyard Sound moat and the insular privileges of nature, tradition, and way of life. Week by week, the Gazette must report the sad, ugly events that mark off unfulfilled responsibilities of an era far removed from the clear simplicity of Hawthorne's time.

But to us, at least, and in a measure that may transcend all meaner circumstances, the old pattern is still clear. It is within our reach as it is within our purpose to live just so—"for a few summer weeks as if this world were heaven." If, in this aim, we seem to be escaping realities, enacting simplistic roles, what then? We have a summer reality, a Vineyard reality within our grasp—just for a few weeks apart, but those few weeks are precious.

And, a serious side to all this, one notes that history is again being rewritten, rewritten in controversy as always, with recognition of new themes, points of view that are old but vital in fresh relevance. It is said that history is always written by winners, but who are the winners, what is the philosophy or political mode that can claim victory in the context of this decade?

So we look back, or many of us do, and discover where the wrong turns were taken and lessons unlearned. In the emerging central direction, this Island summer, lived as if the world were heaven, may be not only a respite but a return to a more reasonable expenditure of all resources in the term of man on earth. The little, all too little as it seems, may be a token of the great.

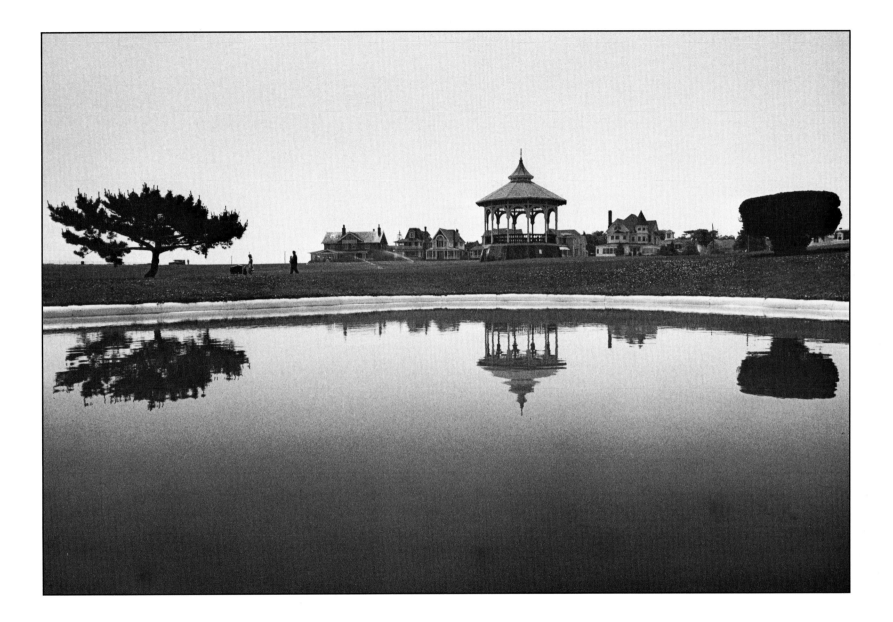

THERE IS A COMRADESHIP of a summer Island that one may compare with the comradeship of a vessel at sea on which many strangers, a diverse company by and large, have engaged passage with only one common aim, to get to the same place. In the case of the Island the common aim is a sharing of summer resources of country, shore, and sea; yet summer is a kind of passage, also, and a vacation is a kind of journey.

So one looks about and sees the shipmates of the season making the most of their allotted time before they must be put ashore, some at one place, some at another, some near, some far off, to go about business as miscellaneous and inscrutable as economics or geography or any of the permanent mysteries.

Strangers as they may be, they wear about themselves a like air of preoccupation that suggests a sharing of emotions and attitudes, not merely of external experience. But there is plenty of the latter, too, and it is the occasion of special costumes—the bright raiment now prescribed for outdoors and summer. All the more apt, then, the metaphor of a voyage, reinforced here by the sound of waves, the flash of white hulls, and the horizon separating the blue of the sky and the blue of the sea.

So many strangers, so many different minds and backgrounds, so many different characters, tastes, and for that matter, hopes and fears—and all here together on the voyage of the summer season. Should not this be a uniting thought?

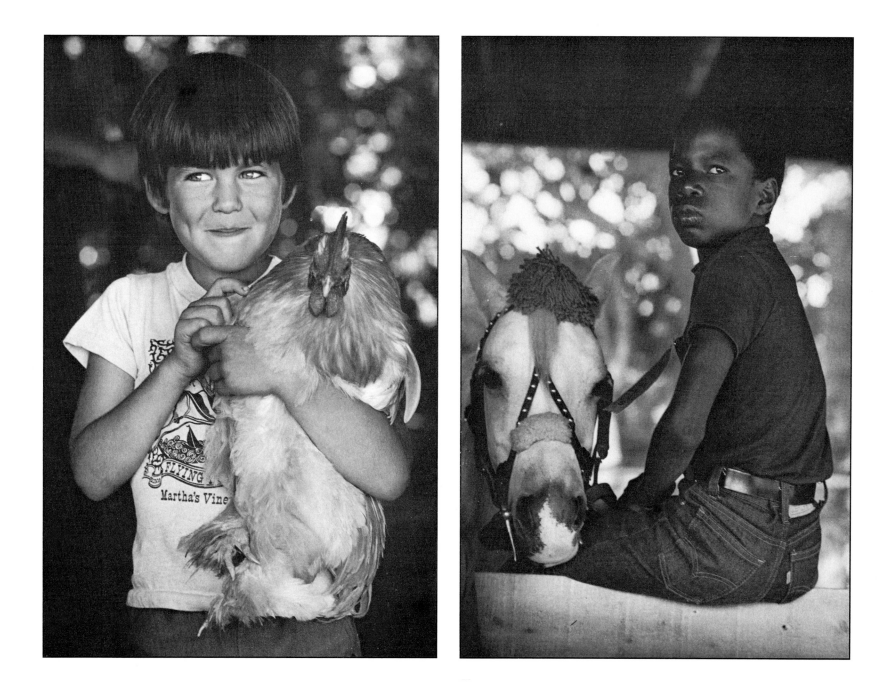

IT WON'T WAIT, this summer that needs to be clutched here and now. The tawny lilies have been abloom for days, orange milkweed is beginning to flame, Susan of the black eyes is out in the old, old fields, the spikes on the sweet pepperbush are well along. The cattails are still young and slim, but they are musk-colored and ambitious in the marshes. Yarrow, Queen Anne's lace, clover, St. John's–wort, and their goodly summer company have been emancipated by both calendar and sun.

Wild roses are making paths and pastures as fragrant as any garden. The viburnum is past and the elderberry flowers are in their prime. The rampant common honeysuckle in common places is sweet to the nostrils. The wild morning glory or bindweed opens in the morning, keeps its longest days, and closes again.

The rush and tumult of summer are among its wonders. Headlong it comes and headlong it goes. Long days seem short.

It won't wait, but a funny thing is that those who don't rush get more out of summer than those who do.

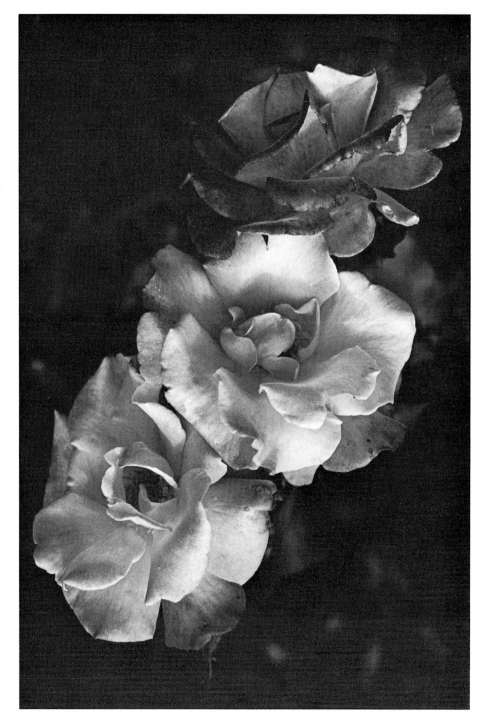

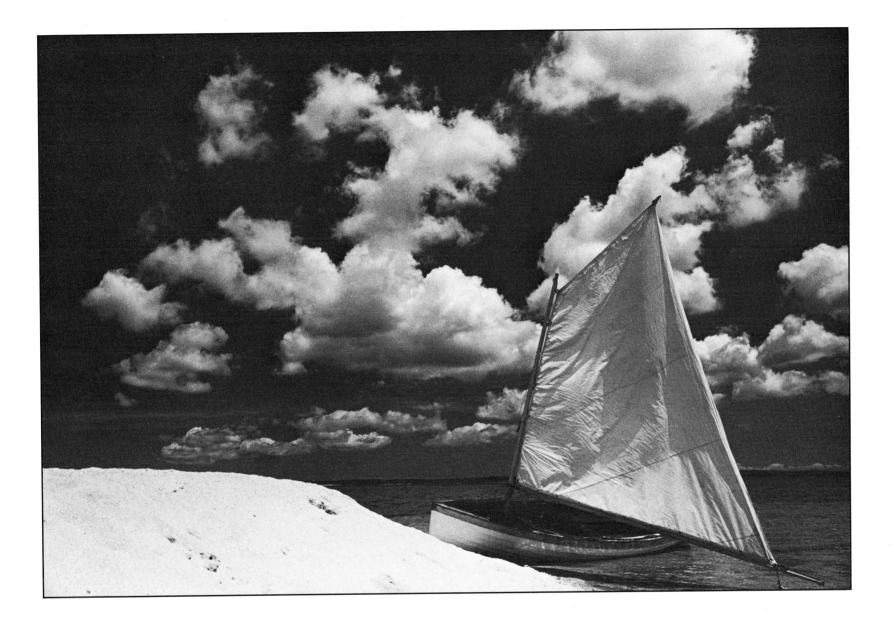

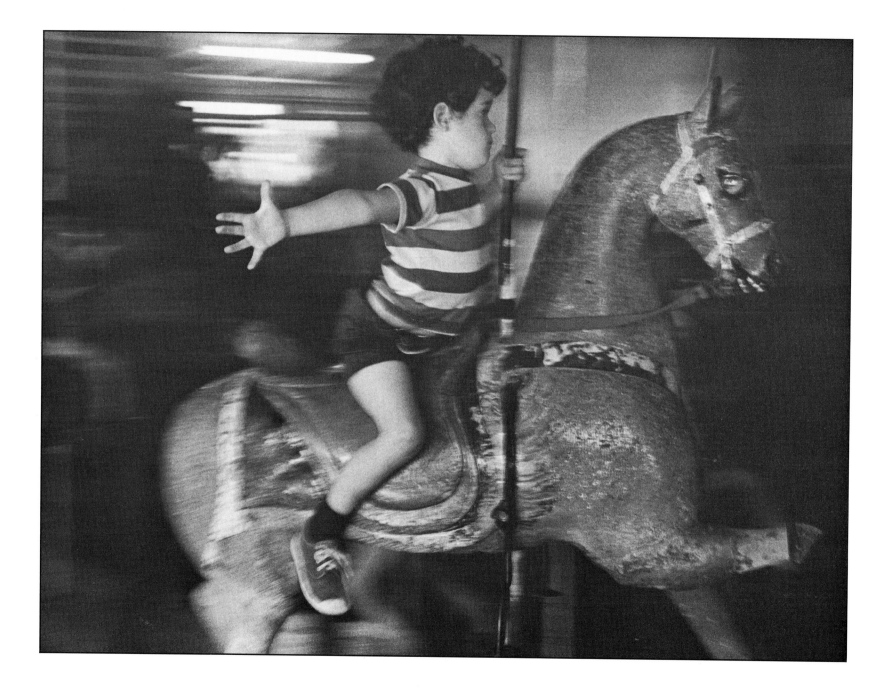

AUTHORITIES SAY THAT A CAROUSEL was at first a tournament, but look at what it has become, at least on Martha's Vineyard—the Flying Horses. In terms of entertainment, this may be included among the valuable improvements of history.

It's the wooden mount a boy rides to the world's end, one arm outflung and the other wisely keeping his hold upon what may be termed his own destiny. He rides with free excitement, and he knows where his horse is going. Knights in tournaments in the old days never knew.

The destination is not so limited and fixed as the circular limit of the Flying Horses seems to require, for the bold boy rider is one of those who rides space and time from one generation to the next. So it has gone with this institution from year to year, a fact that may be put down in the vocabulary of realism, though all the other concerns are fantasy.

The Flying Horses have outridden the advance of pre-colored plastic and molded or stamped-out devices that are offspring of modern technology. They have demonstrated the undoubted eternity of well carved and painted wood, imagination and craftsmanship.

The speed of the Flying Horses is not measurable in r.p.m. It is, basically, a function of the rider's imagination. One who wishes to feel the kinship of aspiration and reality may be referred to the proposal of Tom O'Bedlam to ride to the world's end—"Methinks it is no journey." No one knows whether it was or not, but the rider of a steed on the Flying Horses can come nearest to giving a true account of that cantering journey of the mind.

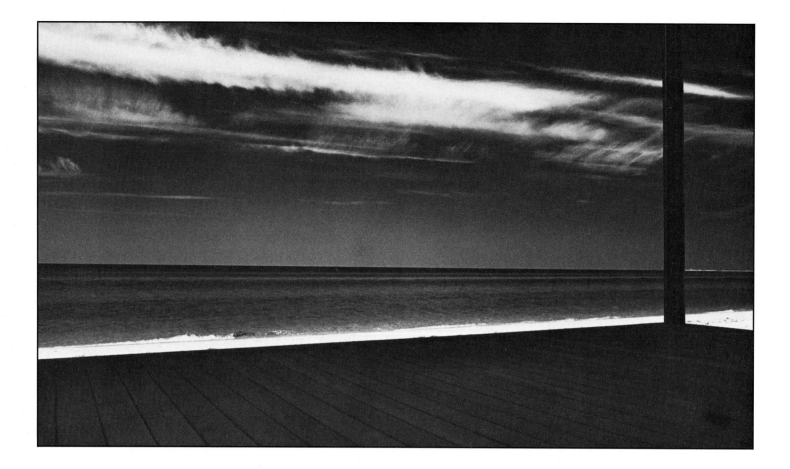

THIS MONTH, the almanacs say, the North Pole is tilted toward the sun, and that is why the days are long and the nights are short. Our people consult the almanacs mostly in winter, to see how much deep snow and ice and suffering is on the schedule. In summer nothing matters much except the tides and the weather, including wind, and all this is taken firsthand, from day to day, not from the pages of an almanac or any other book.

The people on the Island are tilted toward the beaches, and toward the salt water, and most of the newcomers like to have a tiller in their hand and beach sand between their toes. The horseshoe crab is one of the most ancient of the world's creatures and has come down from the remotest millennia of yesterdays, but the summer vacationer is practically eternal and is sure to survive the horse shoe crab in the end. We see the process of evolution in the making, as we see the skins of our guests becoming tanned in the rays of the sun.

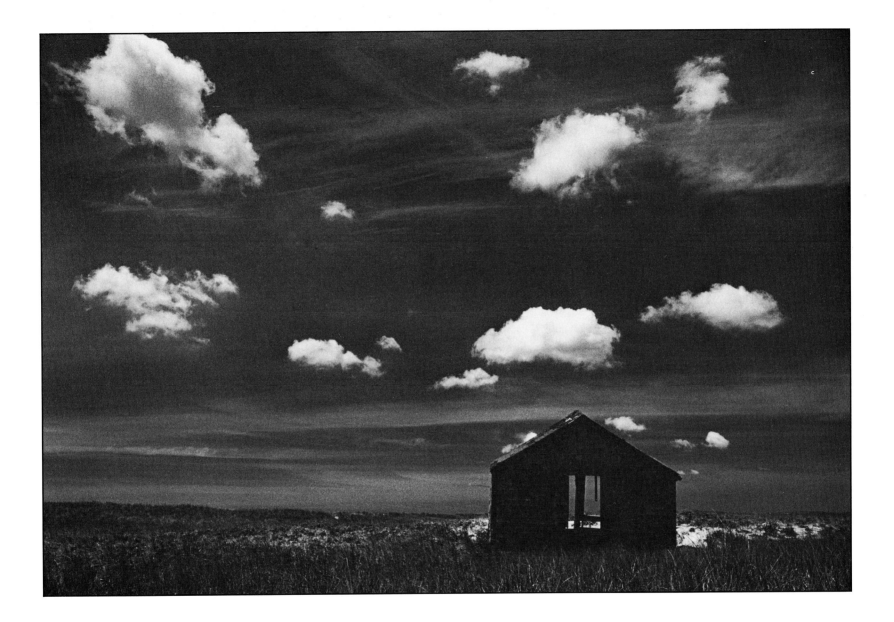

IT'S MANY YEARS now since biologists, fooling around with time as everybody does, concluded that in the life of man "everything occurs as if sidereal time flows four times as fast for a man of fifty as it does for a child of ten. The year, as a consequence, seems much longer to a child." In short, time passes slowly in youth, fast in age.

One may add, on the basis of experience and quite without the aid of biology, that time passes at a deliberate and reluctant rate in winter and gallops in summer. No doubt this is partly due to the heat. If water boils with high temperature, why not time? Of course it boils, and also vaporizes and drifts away into the blue.

Nor can it be doubted that the acceleration of time in the summer is related to the conclusions of the biologists, for summer is the period in which man renews his youth. Each successive round is quicker, and sidereal time is left puffing and blowing far, far behind. Summer represents the maturity of the year, and over and over again it challenges the maturity of the human race.

Even hollyhocks bloom more quickly nowadays than, say, forty years ago, because to remember how they bloomed forty years ago, an observer must be older than that, and for him time has quickened four times over. Fortunate are the children of today for whom the gay, crisp hollyhock flowers climb the stalk slowly, measuring off a brimmingly generous measure of sunny days. Maybe, though, the contemporary young are so precociously occupied that they don't notice hollyhocks, and maybe the gardens within their usual range of observation don't have hollyhocks.

Dr. P. Lecomte du Nouy reports that we have no conception of an absolute time, but only of a physiological time, and that the biological processes in which we live function in a way that varies with the temperature just as do ordinary chemical reactions as described by van Hoff's law. That's just what we were saying.

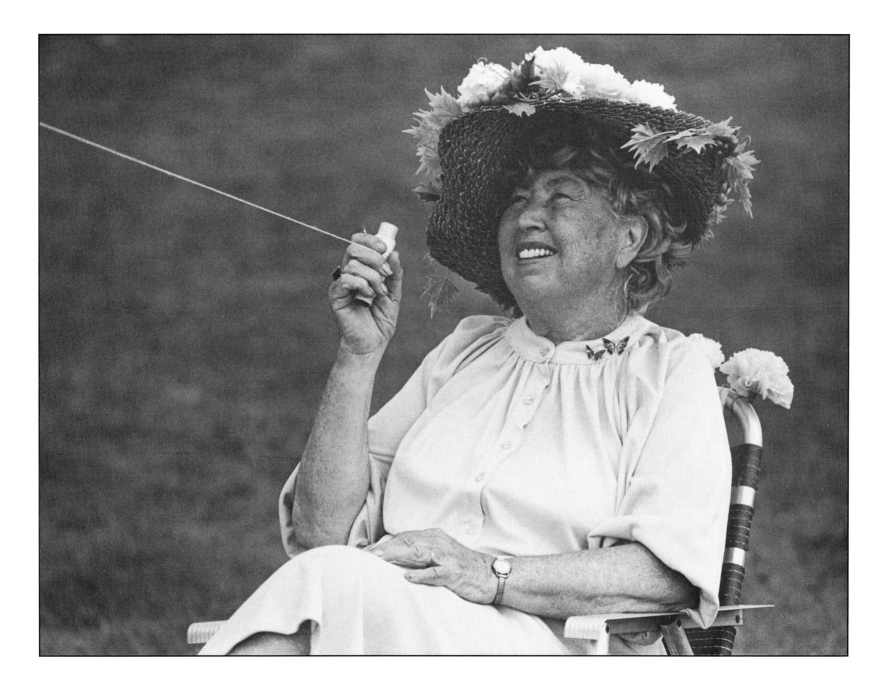

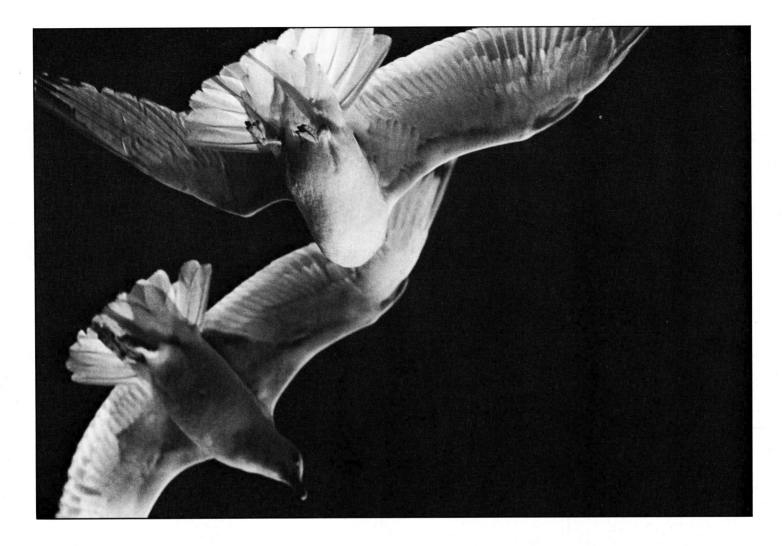

OVERHEAD THE SKY does a certain amount of matching or complementing the water, and now and then takes the lead and puts on the real blue show itself. The intense clarity of the atmosphere provides brilliance and subtlety and the poignant touch; this and the play between flooding sunlight and varied depths and densities of the sea, and the relationship of all to the point of view of the beholder, man, for whom the show seems to have arranged. In return the least we can do is to celebrate these bright and singing blue days.

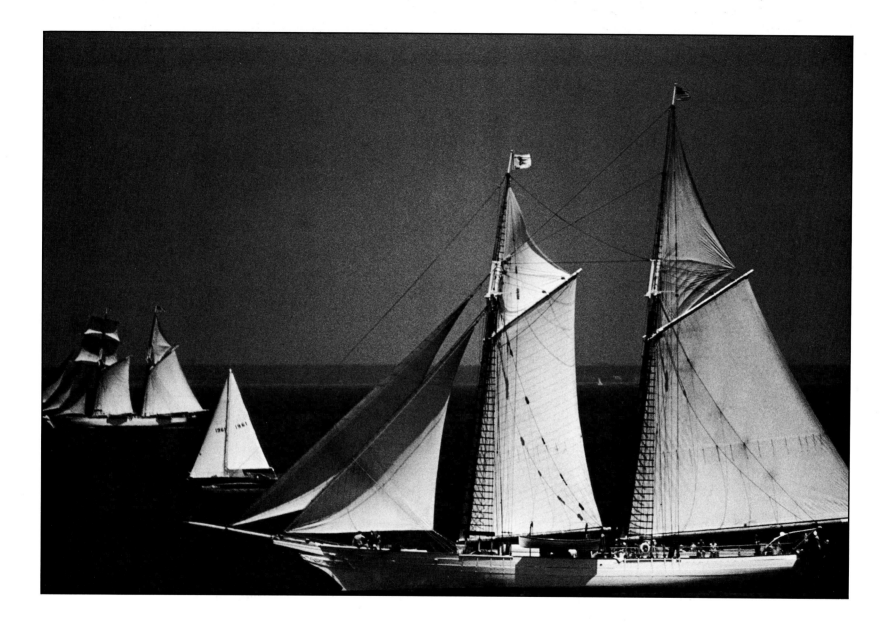

ONCE AGAIN IT'S "HO FOR THE FAIR!" as it has been down through the years, and for three days West Tisbury will assume its annual ranks as the Island's metropolis.

If the fair has changed, so do all things, and the fair at heart is the same, and this is what counts. Some may mourn in their hearts that the annual fairs are held in August instead of at harvest time in the fall when the frost is on the pumpkin and the corn is in the shock. It's a different harvest now, no mistake about that.

Just the same there are exhibits of goats, hares, pigeons, camisoles, jams and jellies, needlework, squashes, pumpkins, handicrafts, breads, cookies, and so on and on. Nowadays there are fiddlers' contests, woodsmen's contests, and displays relevant to the environment, conservation, the Vineyard family, and Vineyardana in general. It's an ancient but very current, timely and lively fair.

There remains the annual challenge to individualism, the creative vision and skill of any Vineyarder, old or young, who has something to offer that he or she has grown or made. Or, as in the case of the newer contests, something that one Vineyarder can do better than others, and is ready to put the matter to the judging at the fair. Resourcefulness has not really paled or gone out of fashion.

The fair must have been always satisfying and it served as an annual reunion for all the towns, but one guesses that it has become more fun. That, too, is a purpose of an annual county fair.

"All roads lead to the fair," says the program, as did the broadside and programs of years past. And so they do, as will again be demonstrated this week.

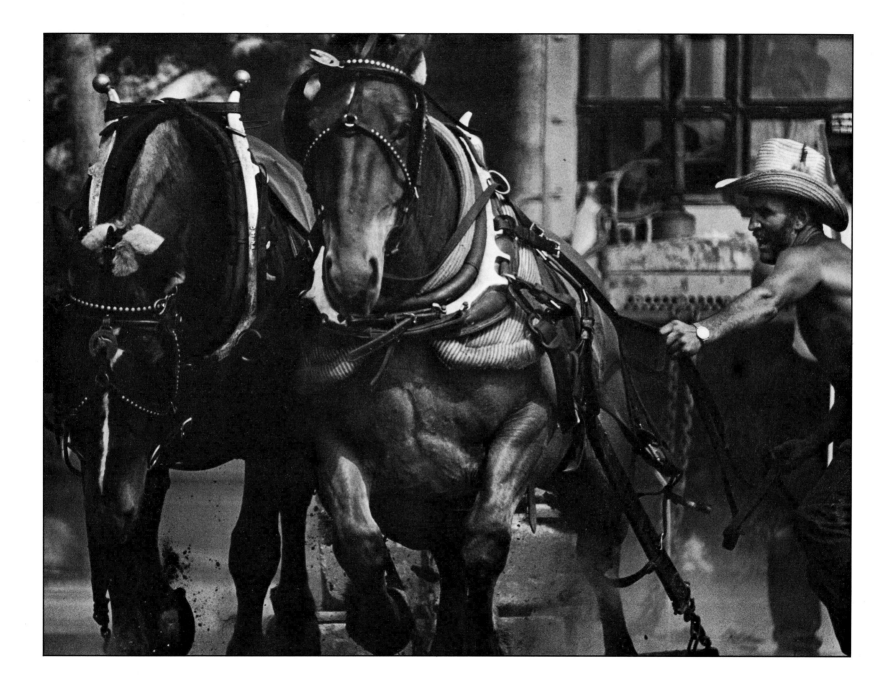

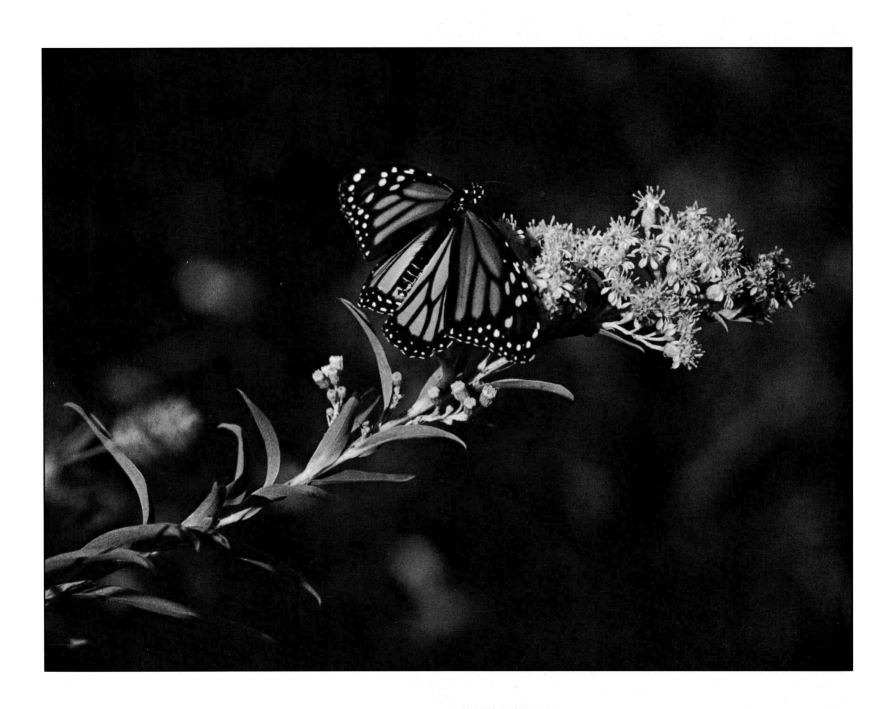

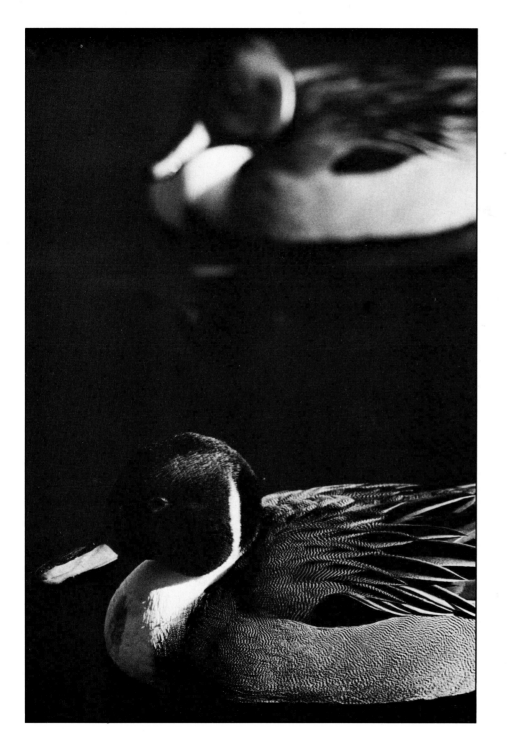

THESE EVENINGS of late summer one may hear in the outer regions of yard and countryside the cicada, crickets, and other choristers making history. Of course modern man assumes that he alone can make history, but that is obviously not so. Weren't the crickets and cicadas here before mankind? We don't remember, and it isn't important; what is important is that there would have been a summer without a single man or woman in the cast of characters—even without a single child.

Despite the history books devoted to such matters, it isn't the activities of man that have provided the continuity of what we call our world, and bound past and present together. Listen to the late summer chanting its independence. Look at the bright, incalculable pattern of stars in the endless sky overhead.

There is an appointment here, but it was not of our making, and our attendance upon it is a privilege. We should conduct ourselves as guests.

Not only nature but our experience is knit together by such slight things as the vibration of the cicada at a proper time. Without these gifts of one season after another there would be no real recurrence, that feast of time in which we may share but play no creative part.

Therefore let us listen with respect and appreciation to the history the crickets and cicadas and all the rest of late summer's mysterious company are making.

It's one of those odd things that the northeast wind which, most of the year, produces three days—at least—of rain and wind, usually raw and bleak, can produce in late summer and early fall the beautiful phenomenon known as a dry northeaster. A northwest day is pretty fine, but the clear northeast day is finest of all, for its air makes the heart lilt and sing.

This is not to say that the northeast day is lyrical, ever, for its mood is more adventurous and daring. One might say, rather, that such a sunny day with ocean air fresh in from the great Atlantic reservoir of boldness and unsullied space turns every human being into a Frobisher or Drake or Columbus. That's the kind of bracing poetry the dry northeaster is.

In the sky the great clouds pile up, but they never darken or obscure the sun more than fleetingly. A mighty architect of clouds the dry northeaster is, piling them up like lofty mountain ranges in the distant sky, and all day long the scene shifts and changes. The imagination is really in the mind of the beholder, just as the poetry is, but both seem to be in the kind of day and in the sun and the clouds and the excitement of the easterly air. Anyway, there can't be this sort of day without the high gallantry that invites mankind, and goes right on inviting.

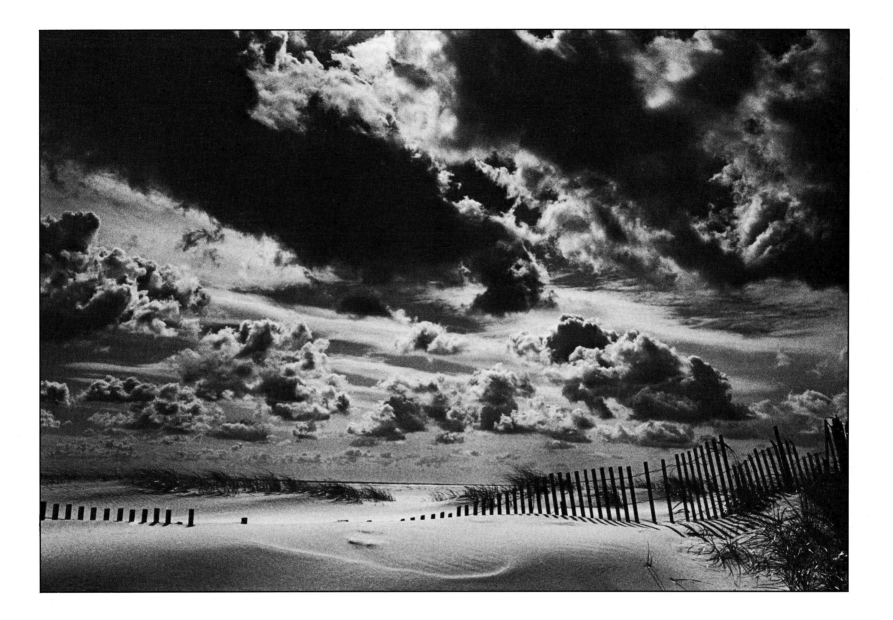

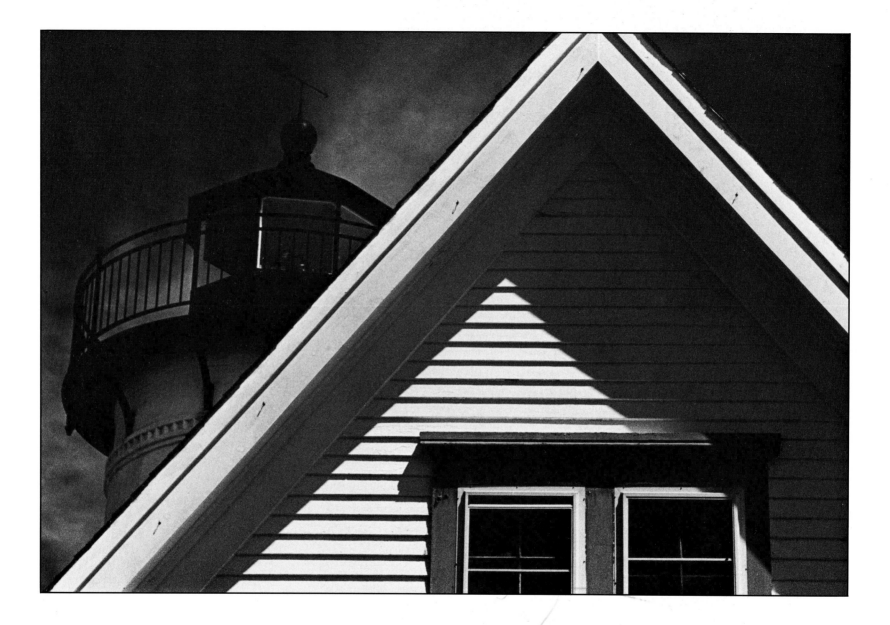

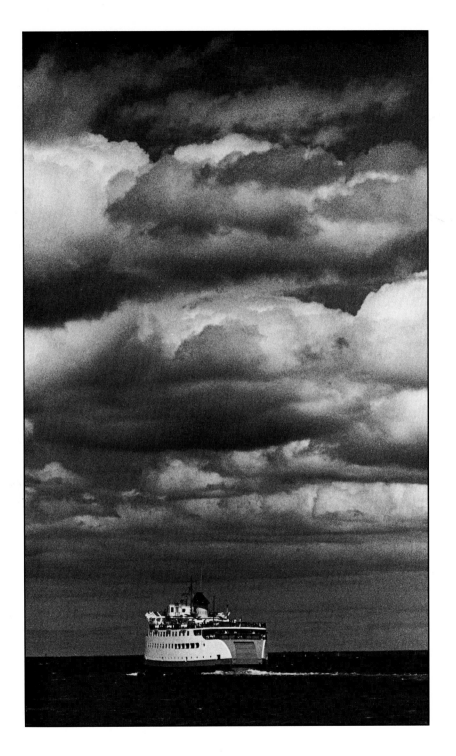

NOTHING IS WHAT it used to be, and therefore the business of going away isn't what it used to be. The greatest change in customs of departure from the Vineyard at the traditional Labor Day festival of retreat has been brought about by the ferry. In the old days the boarding of the steamer was a kind of mass evacuation combined with the ceremony of leaving, say, for Europe or some far place. By comparison, getting on the ferry is a casual affair.

One used to see great heaps of trunks on the wharves, queues of men and women standing in line to check their baggage. There are still trunks, though not so many of them, but by and large the automobile has taken over the function of transporting baggage and chattels. The family packs the car with all it will hold, and off go parents, children, dog, and belongings, in the fashion of the ancient caravan but rather differently propelled.

The more casual departure becomes, the easier it seems to think of coming back. That's a gain. In the old days, after the elaborate staff work and ritual of getting families aboard the steamer, arranging about transfers, baggage, and so on, and standing at the rail and waving goodbye, it seemed almost presumptuous to think of any quick return. But now that you can drive on the ferry, intact, without fuss, and off on the other side, you can face with complacency or even anticipation the prospect of coming back for one weekend or for several.

Those glorious fall weekends are now coming on, and as weather declines on the mainland it still continues to gain on the Vineyard. In the day of departure, keep in mind the anticipation of return.

A PIECE OF LAND or a bit of scenery does not need to be a Grand Canyon or a Garden of the Gods or a redwood forest to be worth preserving. Most of us haven't sufficiently realized that.

The increasing population of the world, the means of transportation which have more and more done away with seclusion and wilderness, the curiosity and enterprise of new generations—all these are forces that are closing in, year after year, upon the once free domain of nature. If this sort of thing continues, there will be nothing untrodden, untamed, or unexploited.

As birds and animals may be rendered extinct by the pressures of what we call civilization, as we know to our bitter regret, all of us, so the face of physical nature may be altered, its expression forever changed. There will be generations and centuries which will never know what this land, sea, and shore were like.

Against so certain a prospect of loss and change, or even of destruction, it is important to set aside preserves, not always great ones, not always far off among mountains, lakes, or deserts, not always superlative in grandeur or traditional beauty. Does anyone ask, "What is it good for?" It does not have to be good for something; it is good.

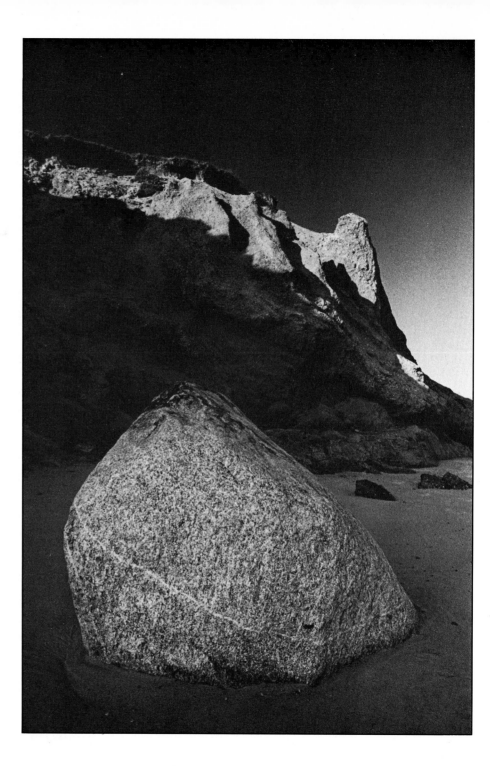

SEPTEMBER is a month with a view. At first blush this seems a peculiar observation since everybody knows that sharper horizons can be seen in the hard, clear air of winter, and the September vistas are still closed in by foliage, ground fogs at night, and lazy, meditative haze when the sun comes up. Like all other months, too, September defies generalization when it chooses. It has its punctuation of rain, chill, northeasterly weather, and so on. We say only that these variants run alongside the main thesis without causing it to waver very much.

The pause is the thing in September. Relaxation comes almost to the minute as we tear off the August sheet from the calendar. August—how importantly hot, glaring, shady, buzzing, and active it was, and suddenly it's over. The stars are in their courses as we all can so well see, the moon fulls, the sun rises and sets, but where is August and all its ways? Over. We wait for what comes next.

A pause is for looking around, and for looking around one can find no climatic or meteorological opportunity better than September, heaven-sent interlude. The days of the month are full and separate. They go by in a rhythm of peace. One will look in vain for a point in September time. No hour or second or minute can be sharpened that much. In the best sense of a term so recently popular, September is a happening, and you don't really know it's happened until its immemorial thirty days are past.

The view then is partly interior and partly exterior, and maybe it isn't as long a view as it seems, except when one lies on a hill or a shore at night, eyes directed upward. But it's a view well-lighted night or day, and for this illumination alone we would be glad to be alive.

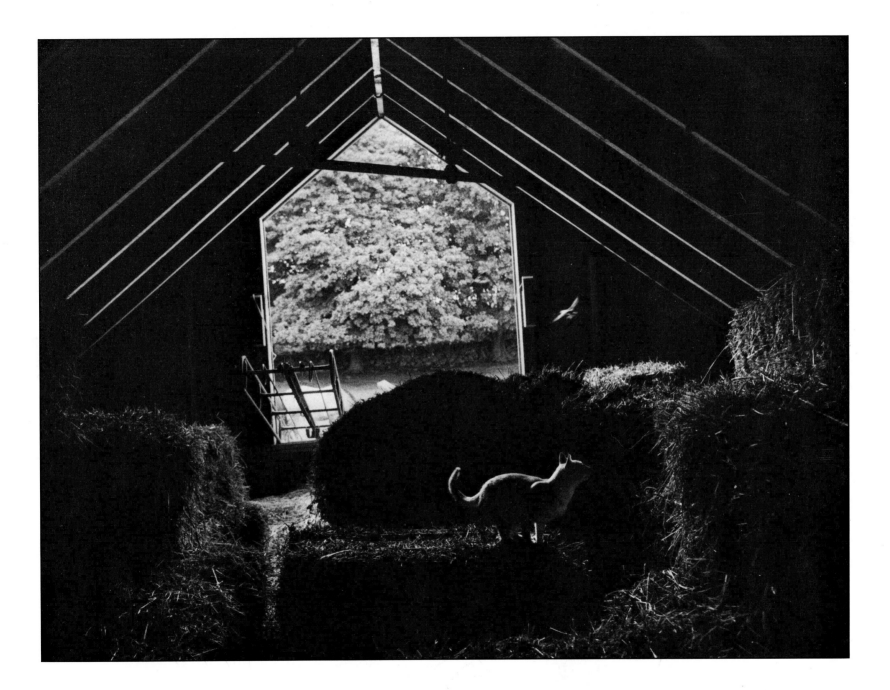

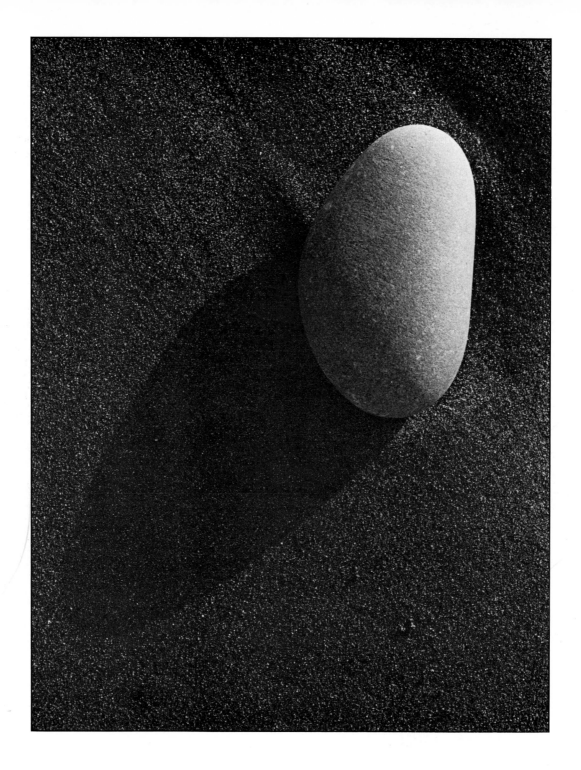

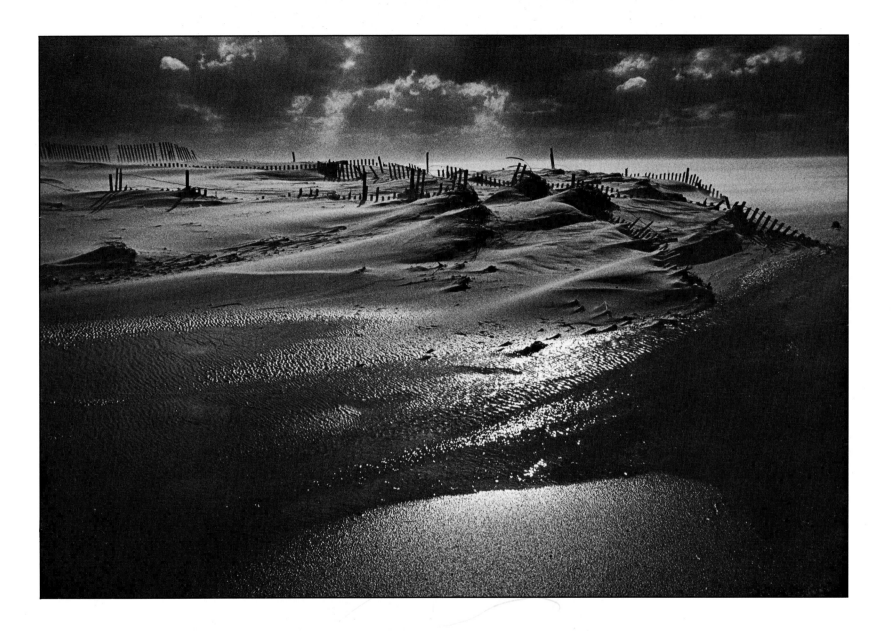

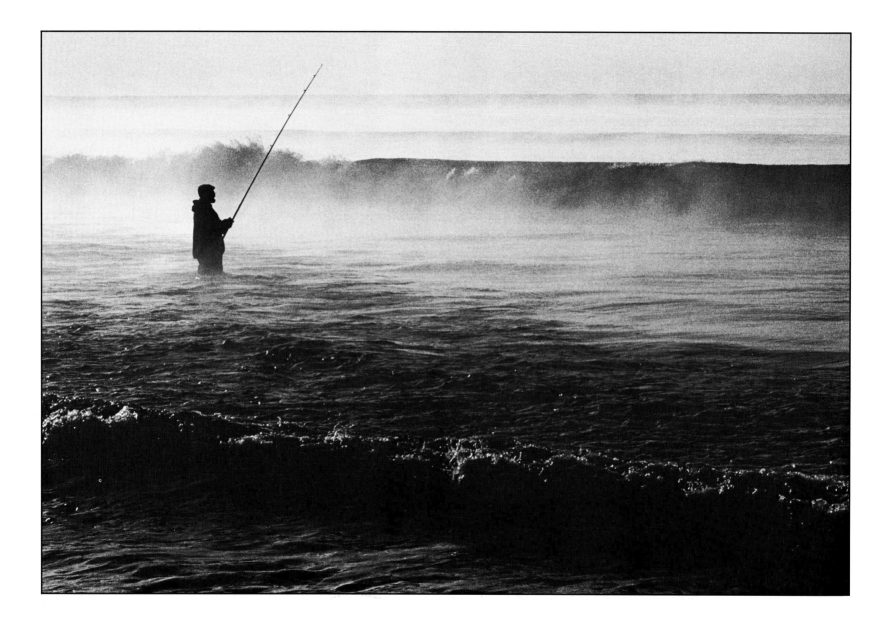

SOMEONE SAID, "How soft it is," and that is a good thing to say of a foggy morning on the Vineyard. It is better to be aware of the softness, the almost caressing quality, or at least the yielding envelopment, of the fog that comes from our sea than it is to complain of the moisture. The fog is part of the element in which we of Islands and coastal places will always live, and part of a heritage that goes back to the eons when all was sea.

Those humans who like to be dry may, we suppose, go to Arizona where we hear there are deserts, hot suns, and landscapes of tawny hues except in the mountains. But there are many Arizonans, and residents of other southwestern and sunny states who come all the way to the Vineyard to be near the ocean. If you are near the ocean, you are near fog. You live with it, and if it were not here you would—no matter how much you prefer the bright, dry northwesters and northeasters—be sorely deprived.

Fog does not like to be resisted. Offshore, it has its dangers, but it is a friendly phase of the atmosphere, and is welcomed by most lungs when it is breathed deeply. As it softens the air and changes the shape and size of objects dimly seen, playing tricks on those who find familiar scenes distorted and odd proportions suddenly introduced, so also it plays with sounds, and with smells. An older generation misses the foghorns, the droning, continuing utterance of tugs and steamers, especially the old tramp steamers, proceeding through the Sound.

The conventional expression for a saturated, dense fog is "pea soup," which is descriptive as to thickness, but not as to feeling or flavor. The softness is not suggested, that gentle envelopment of a September morning when one walks out into the yielding atmosphere that is part sea, part the history of mankind, and part air.

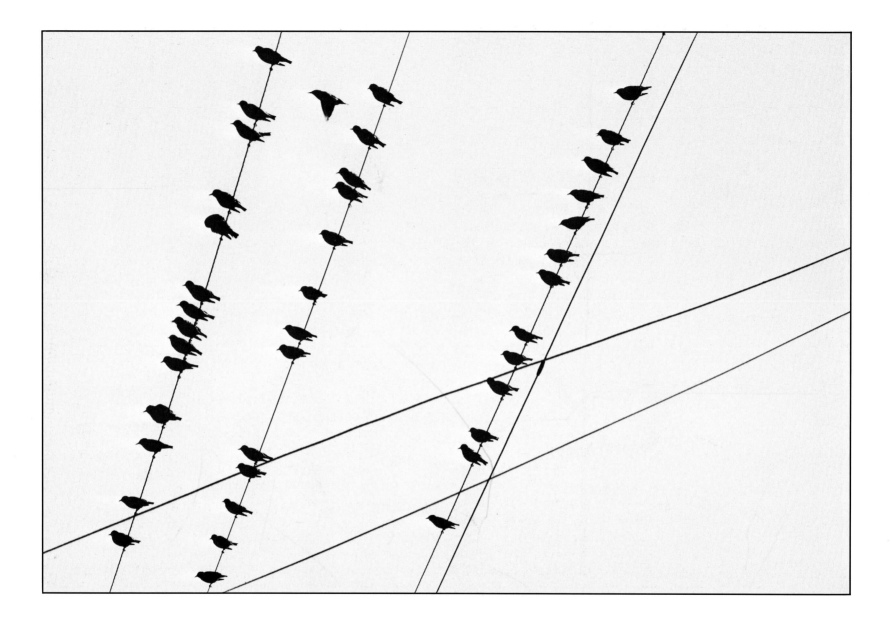

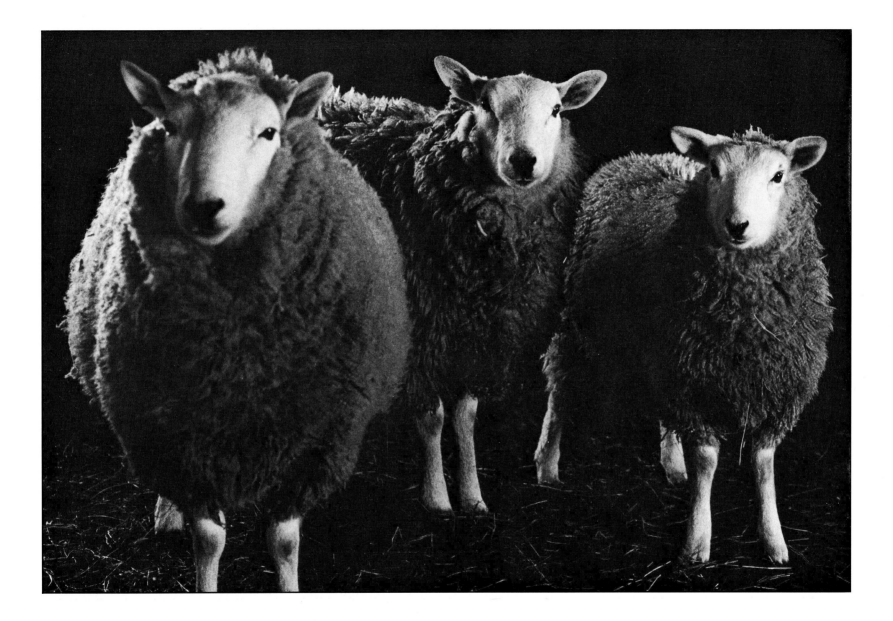

H<small>AS IT NOT</small> been said that the sea is at once the cradle and the home of life? Our origins to a large extent are there, held from old, old time in a cradling hand. So now let us go down to the sea again, on an island, and on ships of a kind, if so preferred. These are waters to sail on as well as to swim in and to contemplate.

The mainland is all right in its way, but its way is necessarily imperfect. Only an island has a shoreline that never ends and that is yet a present fact rather than a distant understanding. Only an island has the sea-intimacy and the level, friendly gaze of a really wise horizon.

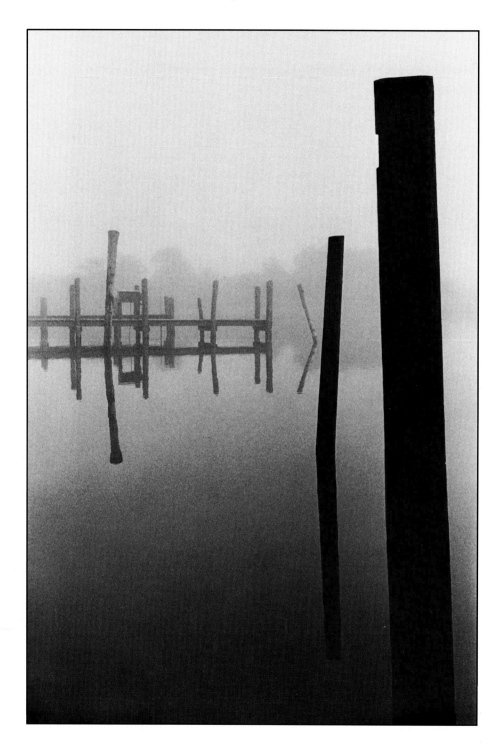

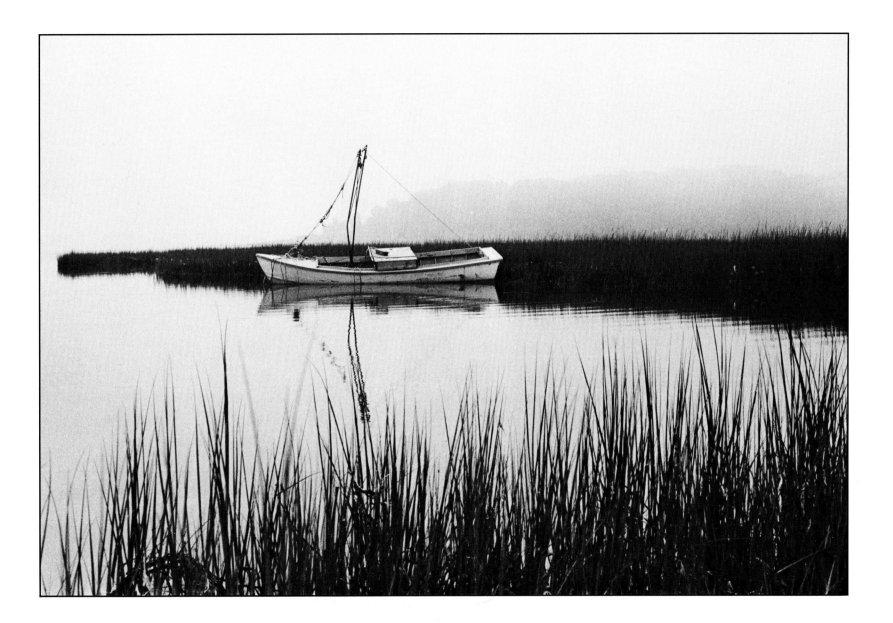

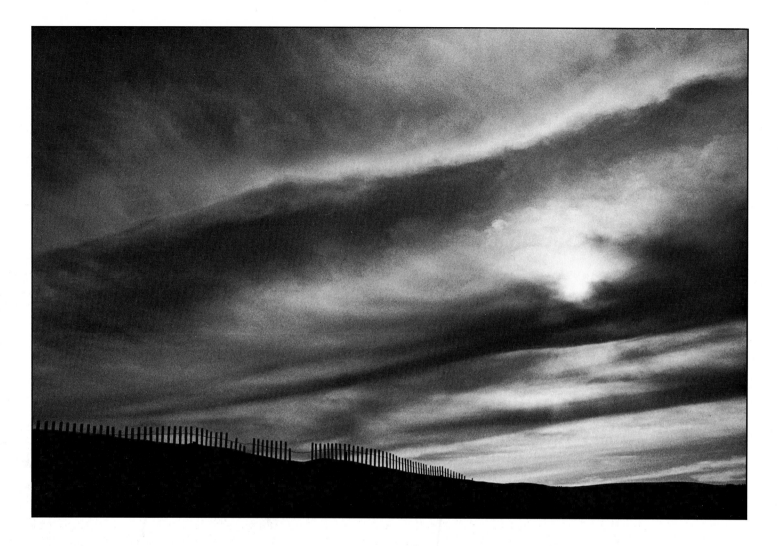

A LITTLE LESS OF SUMMER overhead and a little more of autumn underfoot; then a little less of autumn overhead and a little more of winter underfoot—and that's how the year comes to its long resolution. There's been no haste this time; there almost never is on the Vineyard. The changes, though determined since some remote morning twilight of our world's life, seem impulsive, subject to whim.

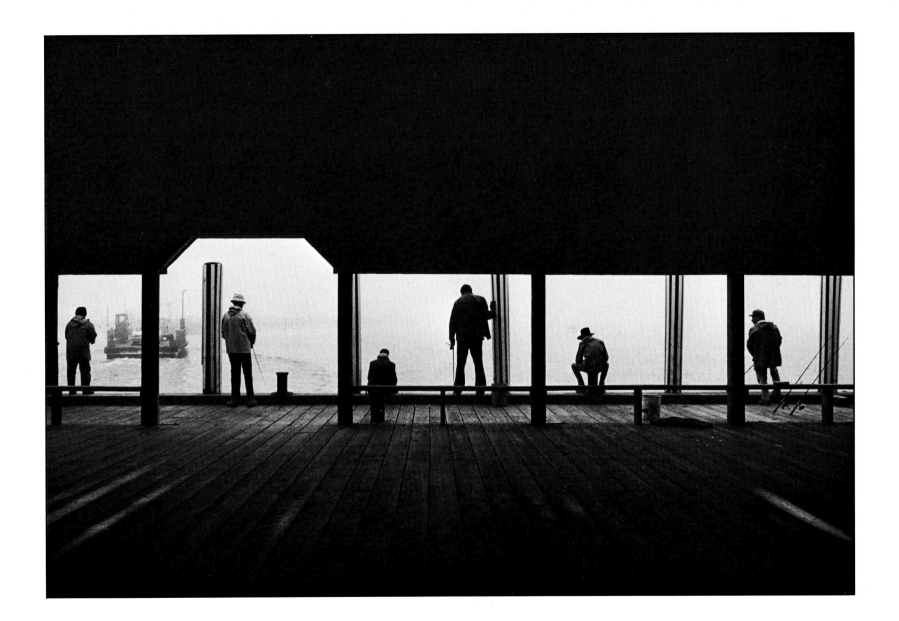

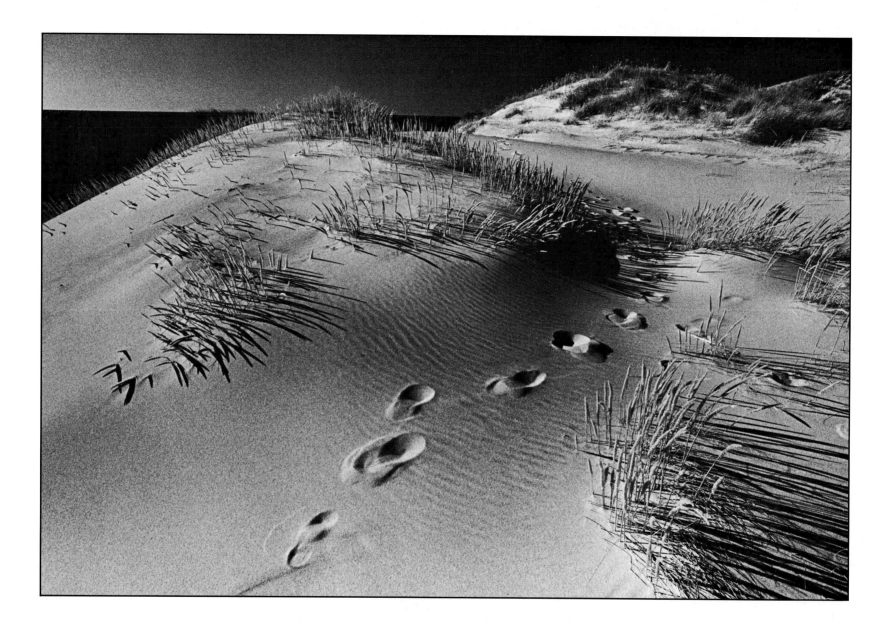

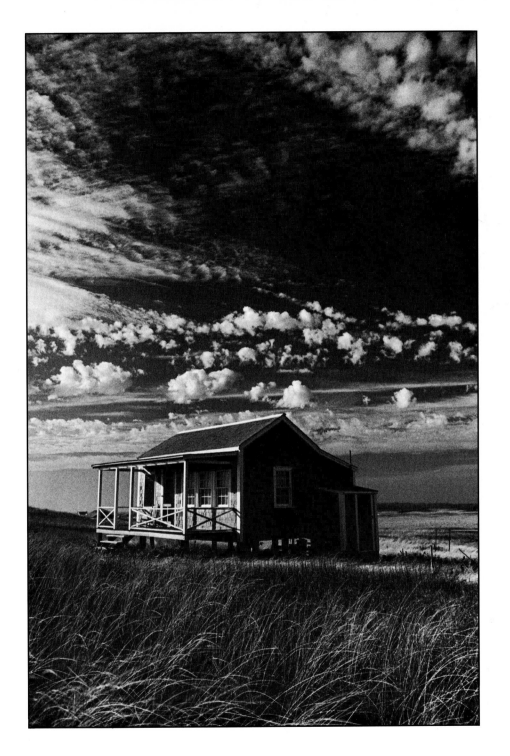

Indian summer has been hanging about of late, and the more of it there is in the slant, mellow, golden rays of the sun, and in the haze that should come from ancient Indian fires but really doesn't, the more of it there is also in the human heart. Talk about spring! Hereabouts, and we suspect in all New England, it isn't a patch on Indian summer.

An average spring on the Vineyard would probably distill out 10 percent poetry, 40 percent hope, and, say, 50 percent impatience. Any Indian summer day will distill out so much poetry, nostalgia, and general admiration for the life that could be—and should be—if mankind would only let it, that these ingredients could be kept together only under pressure. They escape and drift away, and as much remains as before.

Though here and there the swamp maples adopt their habitual colors, the season is not much for display this time. A five day northeaster damaged the foliage, and an early frost darkened the scrub oak and huckleberry bushes of the central plain. The center of the stage is therefore occupied by the oaks, tenacious of leaves, exhibiting all shades of brown and tan and leather, with gold where the sunlight strikes just right.

But, oh the sky! And, oh, the sea! There hasn't been such poignant blue since the last time. And at night the stars, in retreat since the Milky Way pageantry of August, glow in the dark secrecy of space.

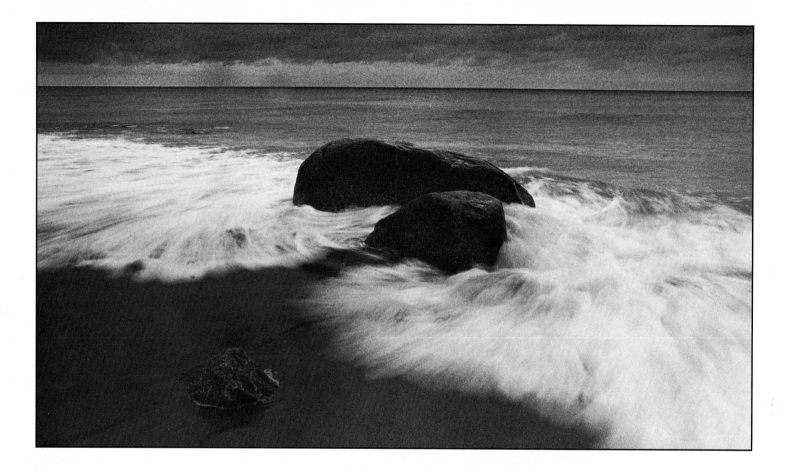

MOST ART, as we understand, is a matter of putting things together, but the art of fall is a matter of pulling them apart, abrading, dissolving, fragmenting, fading, and in general, wrecking what spring and summer have produced. Oddly enough, it is a high form of art, one in which a sensitive observer may find more uplift for the spirit than pathos or depression.

Frost is celebrated as the prime agent of autumn, but rain should not be underestimated. The downpour of Monday night and Tuesday morning, in which almost three inches descended between dark and daylight, is a case in point. The outdoors was greatly altered.

Its sodden aspect was to be expected, and so by those attuned to fall procedures were the littering and diffusing and overwashing on so general a scale that to particularize would be difficult. But no one could have foreseen the change in flavor, almost in taste, that the rain was to produce.

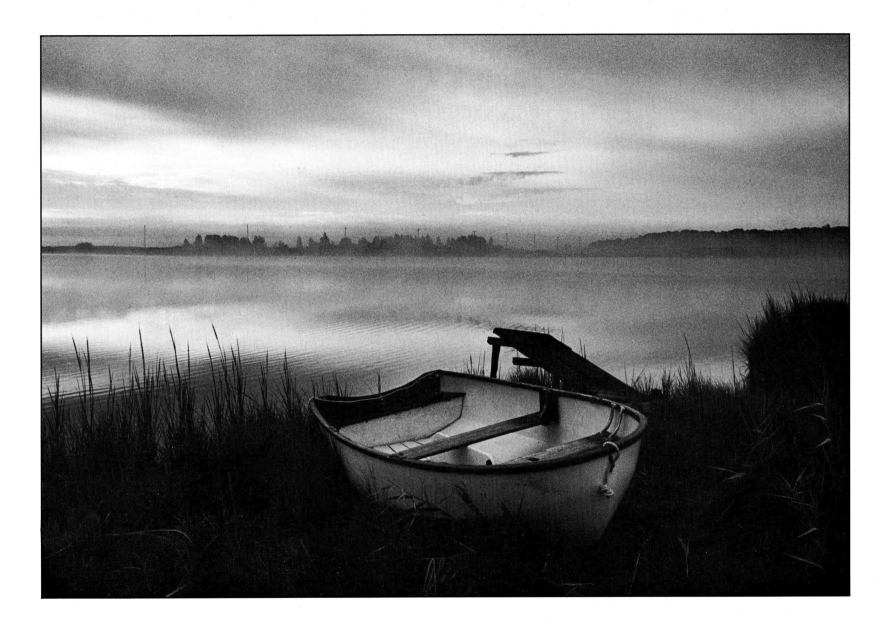

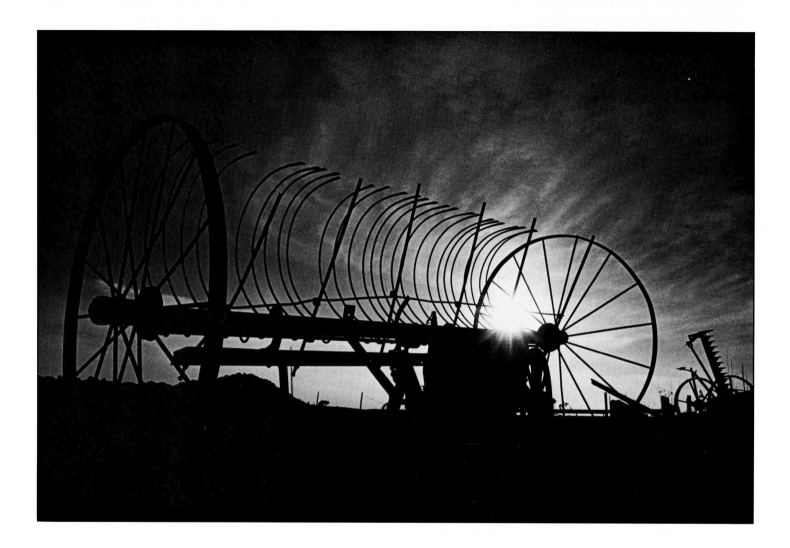

T HE WORD for the countryside is now, or soon will be, "bare," a stark word but often a brave one. Martha's Vineyard just misses being outside New England—it was part of New York once, and it flirts with the Gulf Stream, or vice versa, and in the summer season has dreams of tropic seas—but a near miss can be complete, and in this case, as winter sidles towards us, it is at least fairly conclusive. To be aware of the truth, one need only walk abroad now that the foliage has dropped or blown away, and observe with what tenacity and thrifty effort the trees and shrubs maintain their existence. Gone are the dreams of tropic seas; this is New England.

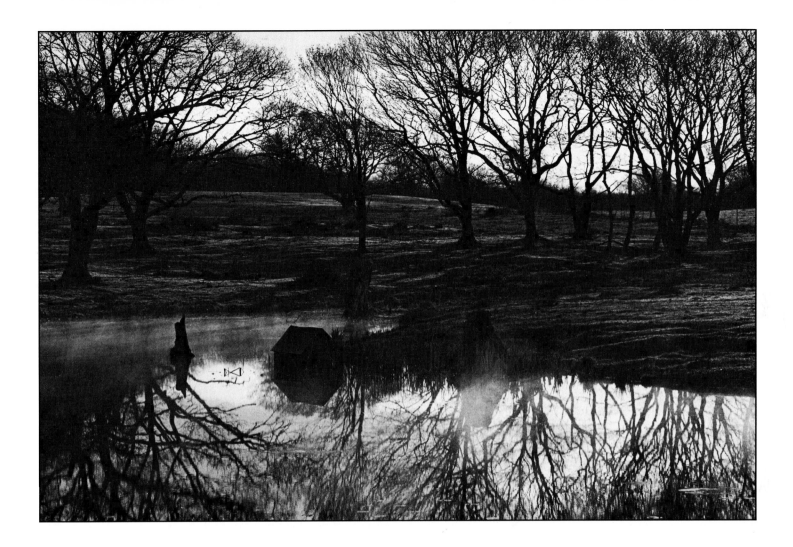

WHAT A LITTLE WHILE AGO seemed—and was—luxurious foliage is to be understood now as mostly fantasy and ambition. All those shimmering leaves, those green hedgerows and tossing plumes, those impenetrable thickets, grew out of scanty, postured, lean stems, twigs, and trunks. Reduced to winter proportions, these stripped supports are lean and naked. Many of them are brittle. They break and toss about in the wind. One thing the skeletal remains do, however: they cast shadows. Across the path or across the road they stretch their thin interruptions of the sunlight, so that when one passes on foot or in a car, the effect is like passing through an old fashioned shutter in a dream.

HERE WE ARE IN November, a month, an age, and a state of mind. This is the time of year when summer seems a long time ago, like photographs put away in an album, or music unheard, or clothes locked in a closet. Every northwester comes as a purge, and every northeaster as one more decisive separation. Summer is "stored away, dry as a faded marigold in the dry, long gathered hay"; so wrote Stephen Vincent Benet, and even though the hay crop was scanty, and there are few barns with sweet-scented, well-packed mows, the image is evocative and real.

The annual miracle of leaves has come, and though we have seen them, green and prodigal, overhead or waving on the horizon for so many months, we are astounded that there should be so many. It would be mistaken to say that all have fallen, yet within a week the woods of the Island have been transformed. The secret ways are open to the sky, the paths and old roads are deeply drifted with rustling, aromatic, abandoned leaves, lying loosely on ground that, over the winter, will gain another layer of mould, another record of the cycle of the trees.

The November sun is warm, but it rises late and sets early. It wavers between reminiscence which is gentle, and anticipation which is bleak. The mood is of transition. Thanksgiving lies just beyond the white morning haze, and Christmas in the ebbing year ahead; we are in the almanac days of November, a month, an age, and a state of mind that has come upon mankind unchanged and unchangeable for as many centuries as man can remember.

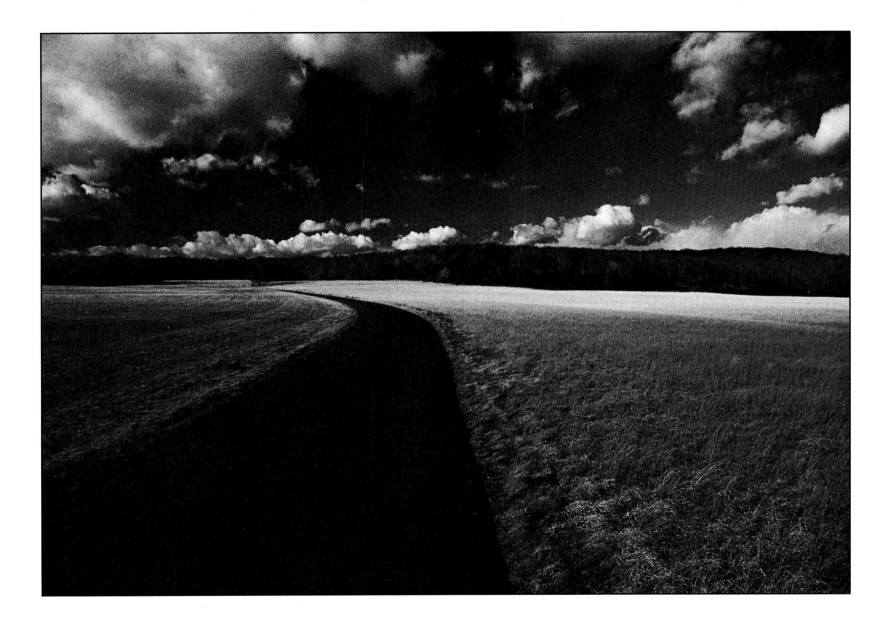

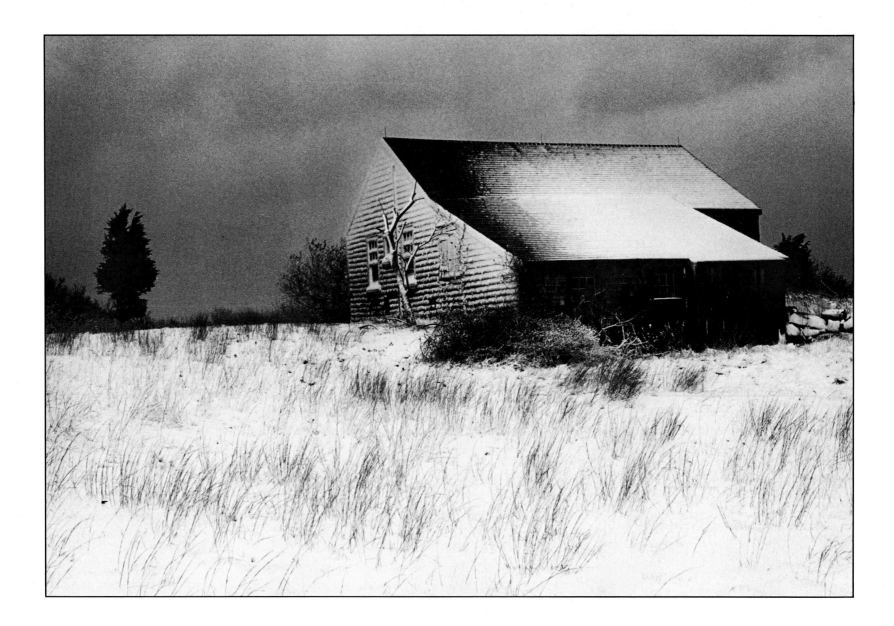

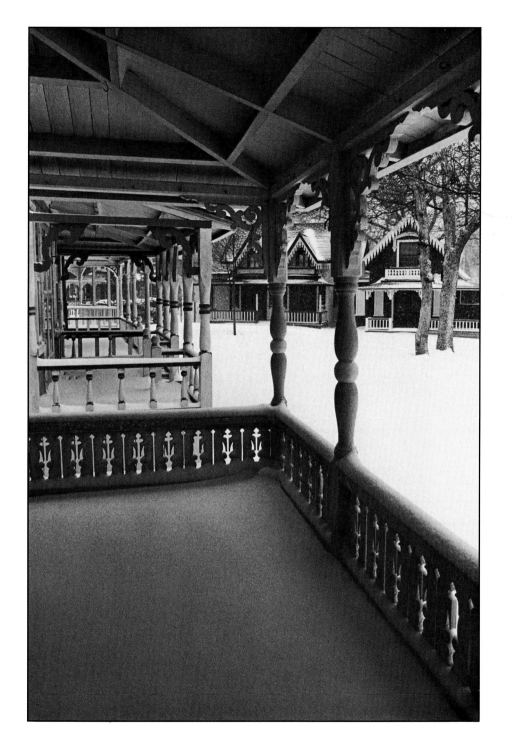

EVERYTHING EARLY has something in its favor—early morning, early evening, early snow, for in these times the experience of being young is renewed again and again in the span of an ordinary lifetime directed mainly toward age. As for early snow, it not only brings renewal of old truths but lays them plainly on the ground.

One is reminded, for instance, that snow melts first of all on the south side of trees and buildings. The wind has most to say about how the snow falls, but as soon as the temperature rises or the sun comes out, geometrical lines and angles are plainly marked where the authority of a southerly exposure begins. Within the areas thus bounded, the snow melts and birds will gather to be fed if there is anyone at home to feed them. Drifts may linger, but often the southern gentleness, though it be imperceptible to humans, bisects them and forecasts the prompt melting of one vulnerable side.

The patterns arrived at by this variation of temperatures are a sequel to similar patterns of summer, made of light and shadow, but they are wholly original with winter. Who would say that the cold season is a season of monotony?

SOMETIMES THE WINTER is surprisingly quiet—no stir at all—as if for a special purpose. That is when, often under a blinking, starry sky, the ponds freeze smoothly with no ridges or bumps or serried overlaps, and the slanting brilliance of sunrise finds its redness magnified by natural mirrors in the Island landscape. That is when, after breakfast, small children—not quite so smallish when they have on mittens, hoods, or whatever best combines warmth and a tone of northern gaiety—are helped with the adjustment of new skates (more sport if they are new)—and they become practitioners in the science of physics.

What the young skater, a little girl perhaps, discovers with the zest of the new winter morning to assist her is how little a push will produce an astonishing glide. She can hardly keep up with herself. Perhaps she has been instructed in the art of skating, with stress on such essentials as remaining upright, but the successive thrusts of slickly equipped feet come by order of her own nature. They cannot be otherwise. And this is a prime example and symbol of winter's willing, sportive motion. When you walk, you merely walk; when you skate, you glide, you travel.

It isn't really the speed that counts so much, though. It's the fact that the skater is in command—not of a machine or device but of several combined laws of nature, the ease of motion and the skill of motion. It's a great exploit when a little girl takes charge of the spirit of the wind.

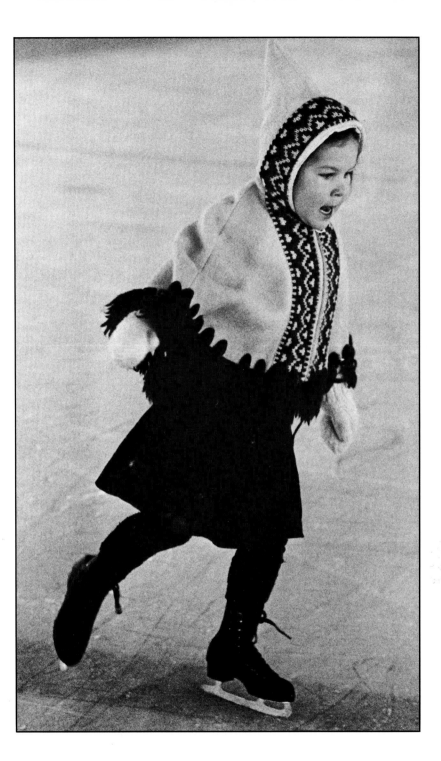

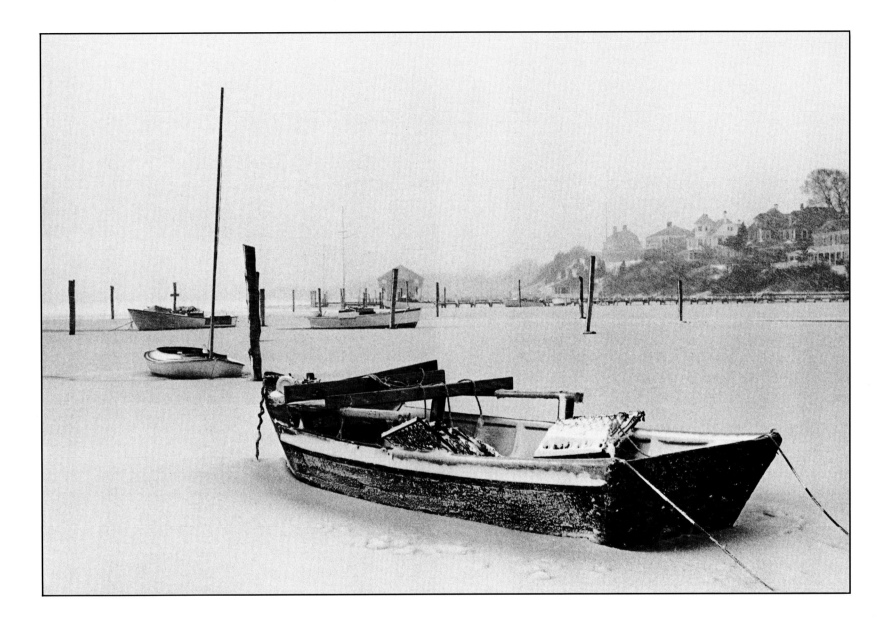

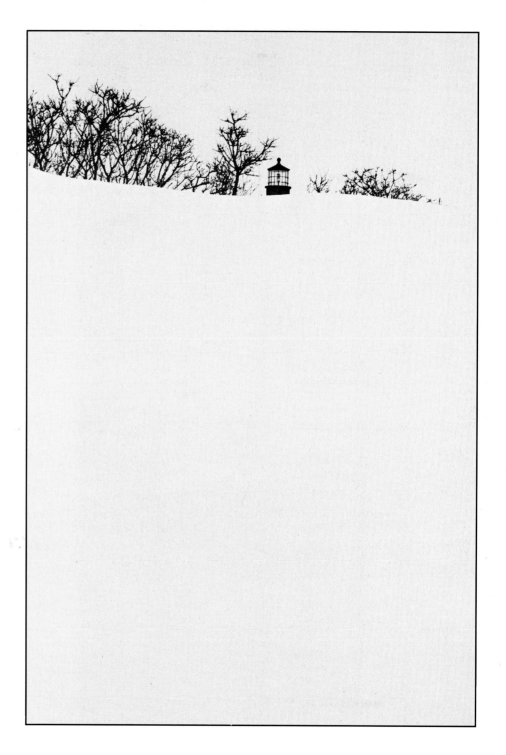

THE MEMORY of snowstorms remains always to claim attention whenever a new storm comes, like the expected rhyming lines of a cherished poem. With a proper snowstorm there is always the great erasure, the familiar world going blank, and seldom at any appropriate time. Seldom, for instance, when many of us would choose to forget the kind of world this is, and pretend to something cleaner and finer. With children there is immediate delight, with adults there is anxiety about the roads and the automobile, the duty of snow shovel and a cleared way to the front gate.

There are no sleighbells any more. Everyone ought to hear sleighbells at least once in an old fashioned snowstorm, in order to remember them afterward. Once remembered, their sound becomes the spring peeping of winter, filling the air with silver-bright sound.

The sculpture of the snow, mock shapes and grotesques, are seen everywhere, and at dusk the ripple and glow of lights on the whitened fields and trees, banked fences and hedges, and rooftops. The world is new again for a time, just a little time before the plows rumble and groan through drifted streets.

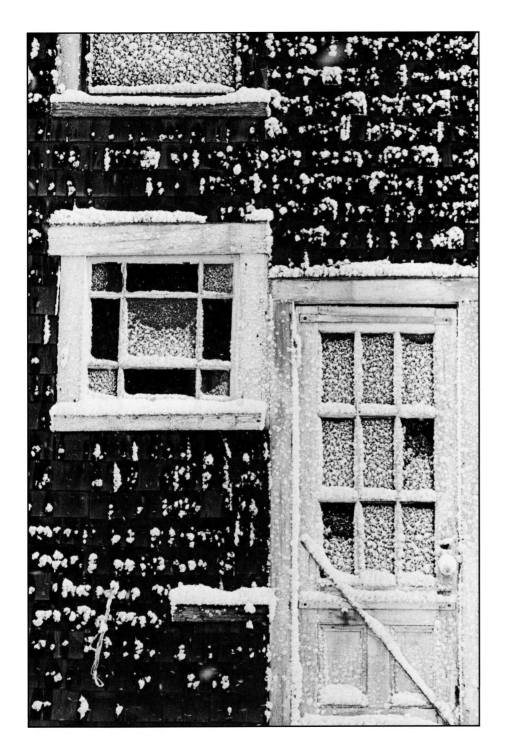

Absent property owners might be diverted and perhaps delighted if they could see their Vineyard houses, secured and shut away for the winter, under the fresh fall of an ample snow. Closed houses invite drifts, festoons, and blankets of snow; there is no warmth or movement within to establish relationship with the outside world. Winter wraps these houses like packages, and along come the icicles in due time to point the whole procedure.

If a passerby were to inquire about one of these white and crystal palaces, he would be told that it was a summer home, surely an undescriptive term. Summer homes are only that in season; in winter they are the delight of the snowstorm and blizzard and could be called the homes of this older, hardier time of the year when the chill inside and the chill outside seek a level.

Through such devices are erased the memories of last year, so that the spring of this year may bring in sights and experiences wholly fresh and new.

THOSE WHO BELIEVE that the warmer months, especially spring, offer the best weather for walkers are badly mistaken. No one can argue against the freshening rediscovery that comes with a sunny morning in April or May—or even sometimes in March—when we arrive again where we would always be, ourselves as reborn as the season of the year. But getting acquainted with winter is a quickening and robust experience, much rewarding. No one has a right to dislike the cold weather unless he has first met it afoot on its own ground.

This involves the ordained trial and error to which mankind is subject, but not much of the latter. Quick learners manage their winter walks after no more than a day or two.

Henry Thoreau on a cold late January day in 1852 observed that "when the thermometer is down to 20, the streams of thought tinkle underneath like the rivers under the ice. Thought, like the ocean, is nearly of one temperature" Many of us have heard the tinkling sound without knowing what it was and without realizing the special kind of hearing that brought it above the level of consciousness. Technically, realists will remind us today, we are talking about a non-sound, but a non-sound is as good as the other kind if you can hear it. Maybe even better if it is your own and if you take it home with you from a winter walk.

"In winter," Thoreau said, "we will think brave, hardy and most native thoughts." And again, "He whom the weather disappoints, disappoints himself." Turn off those misbegotten radio forecasts; what will be, will be, and our thoughts can take it.

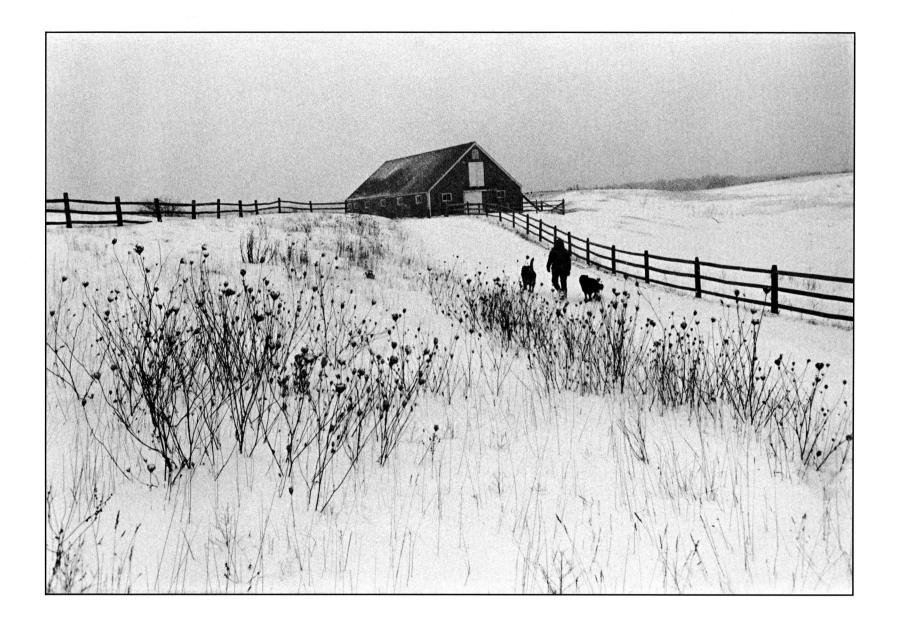

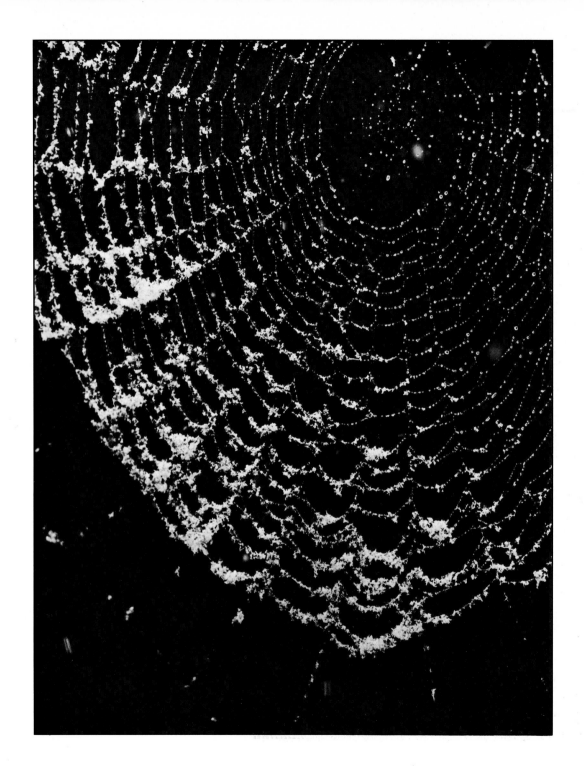

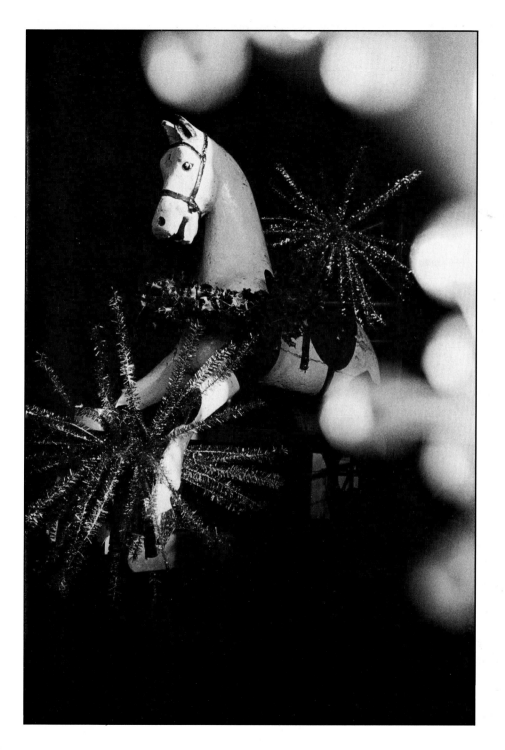

THE FIRST PRIORITY is Christmas—Christmas coming, with the cheer of gay lights in the December darkness, the familiar sound of carols, the voices in stores and along the streets where shoppers gather or stroll, and most of all with the anticipation that grows day by day and especially night after night under the stars.

The season is one of the immemorial appointments of our years and of our lives, perhaps the greatest of all recurrences observed from infancy to age and from generation to generation. Its universality in the world we know and in the affairs in which we are participants is unmatched.

There is commerce and urgency and worry, but the spirit of these December weeks absorbs all else and remains the blessed justification of what becomes, again and again in human experience, a wonderful wholeness, a triumph both of the tangible and the intangible.

The first priority is Christmas. Trees are decorated, parties are planned, homecomings are arranged, wherever one looks or becomes aware, good will emerges more and more. Out of the darkness and bitter cold the lights gleam, and Christmas resumes its eternal warmth.

AMONG THE MERITS of Martha's Vineyard which we should like to urge for the consideration of prospective visitors to this Island, and of all others who may not have thought of it properly, is this: it is the last stop.

So far as the restless, noisy rattle, beat, drone, throb, and roar of traffic is concerned, the Vineyard is not concerned with it. We are beyond it. In relative terms, if there are any such left, we are the ultimate. We are the land in the sea that lies beyond the land.

The Vineyard is not a way station, it is a destination. It is not a place to pass by but a place to stop. It has nothing to do with rush and hurry, it is in a state of rest.

In the modern world in which the craze to go somewhere in a hurry becomes more frantic every year, and in which highways have precedence over nature and the rights of man alike, Martha's Vineyard offers sanctuary and solace. It is a place to arrive, period. Next stop? Don't give it a thought—there isn't any.

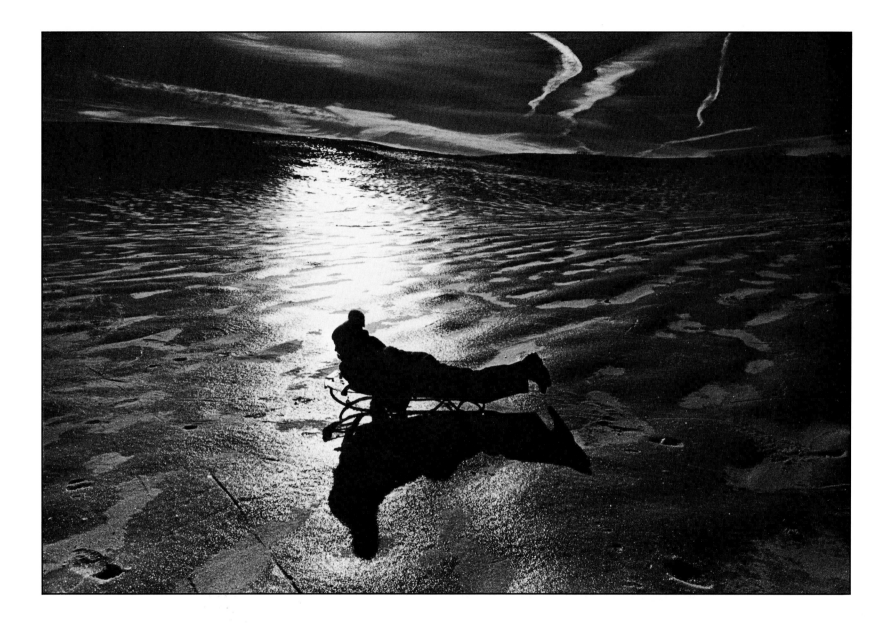

List of Photographs

Acknowledgments

Thank you to Janet Holladay for researching, compiling, and editing the text, and for providing moral support; to Dick and Jody Reston for their advice and encouragement; to Christine Powers for her meticulous typing of the manuscript; to Court Chilton for initiating this project with the Harvard Common Press; and to the staff of the press for their help in carrying it to completion. A very special thank you to the readers and staff of the *Vineyard Gazette* for making this book possible.